MW00476689

Especially for

..

From

..

Date

..

Choose
JESUS

A DAILY
3-MINUTE DEVOTIONAL
FOR WOMEN

BARBOUR
PUBLISHING

© 2022 by Barbour Publishing, Inc.

Print ISBN 978-1-63609-277-5

All rights reserved. No part of this publication may be reproduced or transmitted for commercial purposes, except for brief quotations in printed reviews, without written permission of the publisher. Reproduced text may not be used on the World Wide Web.

Churches and other noncommercial interests may reproduce portions of this book without the express written permission of Barbour Publishing, provided that the text does not exceed 500 words or 5 percent of the entire book, whichever is less, and that the text is not material quoted from another publisher. When reproducing text from this book, include the following credit line: "From *Choose Jesus: A Daily 3-Minute Devotional for Women*, published by Barbour Publishing, Inc. Used by permission."

Readings are excerpted from the devotionals *Choose Joy, Choose Hope, Choose Grace,* and *Choose Prayer.* Copyright © Barbour Publishing, Inc. All rights reserved.

Scripture quotations marked AMP are taken from the Amplified® Bible, Copyright © 2015 by The Lockman Foundation. Used by permission.

Scripture quotations marked CEV are from the Contemporary English Version, Copyright © 1995 by American Bible Society. All rights reserved.

Scripture quotations marked TLB are taken from The Living Bible copyright © 1971 by Tyndale House Foundation. Used by permission of Tyndale House Publishers Inc., Carol Stream, Illinois 60188. All rights reserved. The Living Bible, TLB, and the The Living Bible logo are registered trademarks of Tyndale House Publishers.

Scripture quotations marked MSG are taken from *THE MESSAGE*, copyright © 1993, 2002, 2018 by Eugene H. Peterson. Used by permission of NavPress. All rights reserved. Represented by Tyndale House Publishers, Inc.

Scripture quotations marked NASB are taken from the New American Standard Bible ®, Copyright © 1960, 1971, 1977, 1995, 2020 by The Lockman Foundation. All rights reserved.

Scripture quotations marked NCV are taken from the New Century Version®. Copyright © 2005 by Thomas Nelson. Used by permission. All rights reserved.

Scripture quotations marked NIV are taken from the HOLY BIBLE, NEW INTERNATIONAL VERSION®. NIV®. Copyright © 1973, 1978, 1984, 2011 by Biblica, Inc.™ Used by permission. All rights reserved worldwide.

Scripture quotations marked NKJV are taken from the New King James Version®. Copyright © 1982 by Thomas Nelson, Inc. Used by permission. All rights reserved.

Scripture quotations marked NLT are taken from the *Holy Bible*. New Living Translation copyright© 1996, 2004, 2015 by Tyndale House Foundation. Used by permission of Tyndale House Publishers, Inc. Carol Stream, Illinois 60188. All rights reserved.

Scripture quotations marked NRSV are taken from the New Revised Standard Version Bible, copyright 1989, Division of Christian Education of the National Council of the Churches of Christ in the United States of America. Used by permission. All rights reserved.

Scripture quotations marked KJV are taken from the King James Version of the Bible.

Scripture quotations marked ESV are from The Holy Bible, English Standard Version®. Text Edition: 2016. Copyright © 2001 by Crossway, a publishing ministry of Good News Publishers. The ESV® text has been reproduced in cooperation with and by permission of Good News Publishers. Unauthorized reproduction of this publication is prohibited. All rights reserved.

Scripture quotations marked RSV are from the Revised Standard Version of the Bible, copyright 1952 [2nd edition, 1971] by the Division of Christian Education of the National Council of the Churches of Christ in the United States of America. Used by permission. All rights reserved.

Published by Barbour Publishing, Inc., 1810 Barbour Drive, Uhrichsville, Ohio 44683, www.barbourbooks.com

Our mission is to inspire the world with the life-changing message of the Bible.

Printed in China.

Choose Jesus. . .
and abundant blessings are yours!

Every day, take three minutes to connect your heart with the One who loves you most. When you purposefully choose Him, you'll experience blessings in abundance.

With each turn of the page, you'll experience more joy, more hope, more grace, more faith. . .*more* of those things that bring comfort, encouragement, and peace to your life.

Just three tiny minutes is all you need:

> Minute 1: Read the day's Bible verse and reflect on its meaning.

> Minute 2: Read the devotion and think about its application for your life.

> Minute 3: Pray.

Every day of the year, pause, reflect, and rejuvenate as you immerse your soul in every word of the scripture selections, daily devotions, and prayer starters. Today—and all your days to come—*Choose Jesus*!

Day 1

PRAYERFUL CONSIDERATION

Trust in the LORD with all your heart and lean not on your own understanding; in all your ways submit to him, and he will make your paths straight.

PROVERBS 3:5–6 NIV

Have you ever had to make a decision, but you didn't know what to do? As Christians, we have a reliable resource for counsel. When decision-making poses a threat to our serenity and peace, Proverbs 3:5–6 provides sound advice. . . .

God provides the solution to decision-making with a promise—namely, if we take all our concerns to God, He will direct our paths. When we're tempted to act on our own wisdom, the Lord tells us to stop, reflect, and prayerfully consider each matter. He gives us uncomplicated advice for our major and not-so-major decisions. The question is, will we listen? That's the most important decision of all.

Often, Lord, I run on ahead of You and make decisions on my own. Help me to remember that even with small decisions, I need to seek Your will. Amen.

Day 2

BEAUTY ALL AROUND

*All who seek the L*ORD *will praise him. Their
hearts will rejoice with everlasting joy.*

PSALM 22:26 NLT

Every day, God provides us with beauty all around to cheer and
help us. It may come through the beauty of flowers or the bright
blue sky—or maybe the white snow covering the trees of a glorious
winter wonderland. It may be through the smile of a child or the
grateful face of the one we care for. Each and every day, the Lord
has a special gift to remind us of whose we are and to generate
the joy we need to succeed.

*Lord God, I thank You for Your joy; I thank You for provid-
ing it every day to sustain me. I will be joyful in You. Amen.*

Day 3
EVEN MORE!

*Now unto him that is able to do exceeding abundantly above all
that we ask or think, according to the power that worketh in us.*
Ephesians 3:20 kjv

"Above all that we ask or think" is just that. Imagine every good
thing that God has promised in His Word—or things you've only
dreamed about. Think of wonderful things that exceed the limits
of human comprehension or description, then imagine that God
is able and *willing* to do even more!

The last part of this verse indicates that the Holy Spirit works
within the Christian's life to accomplish the seemingly impossible.
Our highest aspirations are within God's power—but like Paul,
we must pray. When we do, God does far more for us than we
could ever guess.

*Oh Lord, You accomplish things I perceive as impossi-
ble. You know my hopes and dreams, and I believe that
You are able to exceed my greatest expectations. Amen.*

Day 4
STEADY...

People with their minds set on you, you keep completely whole,
steady on their feet, because they keep at it and don't quit.
ISAIAH 26:3 MSG

One of the meanings of *grace* is "an effortless beauty of movement."
A person with this kind of grace doesn't trip over her own feet;
she's not clumsy or awkward, but instead she moves easily, fluidly,
steadily. From a spiritual perspective, most of us stumble quite a
bit—and yet we don't give up. We know that God holds our hands,
and He will keep us steady even when we would otherwise fall
flat on our faces.

Father, I don't always feel so graceful. Thank You for hold-
ing my hand, steadying my feet, and giving me the
strength to keep at it, even when I stumble. Amen.

Day 5
A BOLD REQUEST

When they had crossed, Elijah said to Elisha, "Tell me, what can I do for you before I am taken from you?" "Let me inherit a double portion of your spirit," Elisha replied.

2 KINGS 2:9 NIV

Elijah filled the role of leader, prophet, and miracle worker. Why would Elisha want the heavy responsibilities and difficulties involved in this type of work? He did not ask to have a larger ministry than Elijah—he was only asking to inherit what Elijah was leaving and to be able to carry it on.

What might God give us if we asked boldly for the impossible? God deeply desires to bless us. If our hearts line up with His will and we stay open to His call, He will surprise us. God takes the ordinary and through His power transforms our prayers into the extraordinary—even double-portion requests.

Bless me, Lord. When my heart aligns with Your will and when I ask for the impossible, bless me. Show me beyond my expectations that You are my God. Amen.

Day 6
THE NEW ME

Therefore, if anyone is in Christ, the new creation has come: The old has gone, the new is here!

2 CORINTHIANS 5:17 NIV

Are you in Christ? Is He consistently Lord of your life? Then you are a new creation. *Everything* is new. What's history is done and over—and Jesus has replaced your old with His new: new peace, new joy, new love, new strength. Since God Himself sees us as a new creation, how can we do any less? We need to choose to see ourselves as a new creation too. And we can, through God's grace. Be glad. Give thanks. Live each day as the new creation you have become through Jesus.

Father, I'm so thankful that You are a God of grace— and I thank You that I am a new creation. Please give me the spiritual eyes to see myself as a new creation, looking past the guilt of yesterday's choices. Amen.

Day 7
STRENGTH IN HOPE

I say to myself, "The LORD is my por-
tion; therefore I will wait for him."
LAMENTATIONS 3:24 NIV

In this verse, the writer declares that the Lord is his portion. The Lord is our portion too. But when will we fully receive this inheritance and celebrate with Him? We know it is coming, but it's difficult to wait. Hope gives us strength as we anticipate our return to God. We belong to God and know someday we will worship Him face-to-face in His presence. Knowing God will keep His promise, we can say with confidence, "The LORD is my portion; therefore I will wait."

What an amazing promise You have made to me,
Father, that one day I will be with You in heaven.
My hope is in You as I wait for that day. Amen.

Day 8
LOOK UP!

The heavens declare the glory of God;
the skies proclaim the work of his hands.

PSALM 19:1 NIV

Grace is as near as the sky over your head. Look up and be reminded of how wonderful God truly is. The same God who created the sun and the atmosphere, the stars and the galaxies, the same God who day by day creates a new sunrise and a new sunset, that same God loves you and creates beauty in your life each day!

Father, when I look to the heavens, I am reminded that You are Creator, Giver of grace, and Author of beauty. Thank You for surrounding me with the work of Your hands. Amen.

Day 9

HE WILL ANSWER

*I waited patiently for the LORD; and he inclined unto me, and
heard my cry. He brought me up also out of an horrible pit.*

Psalm 40:1–2 kjv

David found himself trapped in a "horrible pit" with no apparent
way out, and he cried loudly to the Lord to rescue him. Then he
waited. It took time for God to answer. David undoubtedly learned
more patience in the process and probably had to endure doubts,
wondering if God cared about the dilemma he was in.

Today we sometimes find ourselves in a "horrible pit" as well,
and we pray desperately for God to bring us up out of it. He will.
We often just need to be patient.

*Why is patience so hard? It's because Your timing is per-
fect and beyond my understanding. Help me to be patient
with You, God. I know that You will answer me. Amen.*

Day 10

PEOPLE PLEASER VS. GOD PLEASER

We are not trying to please people but God, who tests our hearts.
1 Thessalonians 2:4 niv

When we allow ourselves to be real before God, it doesn't matter what others think. If the God of the universe has accepted us, then who cares about someone else's opinion? It is impossible to please both God and man. We must make a choice. Man looks at the outward appearance, but God looks at the heart. Align your heart with His. Let go of impression management that focuses on outward appearance. Receive God's unconditional love, and enjoy the freedom to be yourself before Him!

*Dear Lord, may I live for You alone. Help me
transition from a people pleaser to a God pleaser. Amen.*

Day 11
KNOW HOPE

*I pray that the eyes of your heart may be enlightened
in order that you may know the hope to which he has
called you, the riches of his glorious inheritance in his holy
people, and his incomparably great power for us who believe.*
 EPHESIANS 1:18–19 NIV

Our heart is central when it comes to God. It's vital for not only our physical life but our spiritual life as well. It's the thinking apparatus of our soul, containing all our thoughts, passions, and desires. Why was Paul so anxious for Christians to make heartfelt spiritual progress? Because of the payoff! God freely offers us His incomparably great power along with a rich, glorious inheritance. We just have to see our need for a little surgery.

*Instill in me a new heart, God. Fill it with Your unrivaled
power and love. Place within it the priceless gift of Jesus'
sacrifice and the promise of eternal life in heaven. Amen.*

Day 12

BY HIS GRACE

*A person is made right with God through
faith, not through obeying the law.*

ROMANS 3:28 NCV

Human laws can never make us into the people we are meant to
be. No matter how scrupulous we try to be, we will always fall
short. Our hands and hearts will come up empty. But as we fix our
eyes on God, committing our lives and ourselves to Him, we are
made right. We are healed and made whole by His grace, exactly
as God meant us to be.

*Father, rather than working to become righteous
in Your sight, help me instead to focus on increas-
ing my faith and trusting in Your grace. Amen.*

Day 13

THY WILL BE DONE

He went away a second time and prayed, "My Father, if it is not possible for this cup to be taken away unless I drink it, may your will be done."

MATTHEW 26:42 NIV

In one of His darkest hours, Jesus was overwhelmed with trouble and sorrow. He asked God for something that God would not provide. But Jesus, perfect and obedient, ended His prayers by saying, "*Your* will be done."

When we face our darkest hours, will we follow Jesus' example? Can we submit to God's perfect will, focusing on how much He loves us—even when His will doesn't match ours?

I wonder why You refuse when I ask for what I think is right. But Your knowledge is greater than my understanding. So Thy will be done, God; Thy perfect will be done. Amen.

Day 14

HE WILL SEND HELP

"The waves of death swirled about me;
the torrents of destruction overwhelmed me. . . .
In my distress I called to the LORD. . . . From his
temple he heard my voice; my cry came to his ears."

2 SAMUEL 22:5, 7 NIV

God never asked us to do life alone. When the waves of death swirl around us and the pounding rain of destruction threatens to overwhelm us, we can cry out to our heavenly Father, knowing that He will not let us drown. He will hear our voice, and He will send help. So, next time you feel that you can't put one foot in front of the other, ask God to send you His strength and energy. He will help you to live out your purpose in this chaotic world.

Lord, thank You for strengthening me when the dailiness of
life, and its various trials, threaten to overwhelm me. Amen.

Day 15

GOD HEARS

I love the LORD because he hears my
voice and my prayer for mercy.
PSALM 116:1 NLT

Psalm 116:1 is a wonderful verse that should not be missed. It is neither lament nor praise, as many of the other psalms are. But it is a strong assurance of hope. Whether we are offering our praise to God or falling at His feet with our struggles, we know from these few words that God hears us. Isn't that mind-blowing? The almighty God of the universe who created and assembled every particle in existence hears us when we come before Him.

I have so many reasons to love You, Lord, so many
reasons to worship and praise You. How grateful I
am that You hear my voice! I love You, Lord. Amen.

Day 16

DAILY MIRACLES

*"That is why I tell you not to worry about everyday life—whether
you have enough food and drink, or enough clothes to wear.
Isn't life more than food, and your body more than clothing?"*

MATTHEW 6:25 NLT

With our eyes fixed on what we don't have, we often overlook
the grace we have already received. God has blessed us in many
ways. Our bodies function day after day in amazing ways we take
for granted, and life is filled with an abundance of daily miracles.
Why do we worry so much about the details when we live in such
a vast sea of daily grace?

*Father, You are my Provider. You have promised to give me
everything I need. Help me to remember this truth and to
lose myself in the vast sea of Your amazing grace. Amen.*

Day 17

GOD ALREADY KNOWS

"As soon as you began to pray, a word went out, which I have come to tell you, for you are highly esteemed."
DANIEL 9:23 NIV

In the middle of pouring out his heart to God one day, Daniel is interrupted by the appearance of the angel Gabriel. Bringing insight and understanding (verse 22), Gabriel's message contains the interesting concept that in the instant that Daniel began to pray, the answer was already on its way.

Before Daniel got past his salutation, God knew Daniel's heart and had already set in motion the response to Daniel's unfinished prayer.

As He did for Daniel, God knows our needs even before we give voice to them in prayer. We can rest in the knowledge that even before the words leave our lips, God has already heard them, and He has already answered them.

Thank You, God, for answering my prayers.
Before the words leave my lips, You already have the
answer. How great You are, God! I praise You. Amen.

Day 18
SHAKE IT UP!

The LORD had said to Abram, "Leave your native country, your relatives, and your father's family, and go to the land that I will show you. . . . I will bless you. . .and you will be a blessing to others."
GENESIS 12:1–2 NLT

In God's wisdom, He likes to shake us up a little, stretch us out of our comfort zone, push us out on a limb. Yet we resist the change, cling to what's known, and try to change His mind with fat, sloppy tears. Are you facing a big change? God wants us to be willing to embrace change that He brings into our lives. Even unbidden change. You may feel as if you're out on a limb, but don't forget that God is the tree trunk. He's not going to let you fall.

Holy, loving Father, in every area of my life,
teach me to trust You more deeply. Amen.

Day 19
HOPE THRIVES

"For I know the plans I have for you," declares
the LORD, "plans to prosper you and not to harm
you, plans to give you hope and a future."
JEREMIAH 29:11 NIV

Hope thrives in the fertile soil of a heart restored by a loving gesture, a compassionate embrace, or an encouraging word. It is one of God's most precious gifts. God *wants* to forgive our sins and lead us on the path of righteousness—just as He did for the Israelites of old. He has great plans for us. That's His promise and our blessed hope.

Father, You provide hope when all seems hopeless.
Trusting in Your plans for me brings me joy. My future is
in Your hands, so how can it be anything but good? Amen.

Day 20
SATISFIED

Satisfy us in the morning with your unfailing love,
that we may sing for joy and be glad all our days.

PSALM 90:14 NIV

God wants to fulfill you. He wants you to feel satisfied with life so that you will catch yourself humming or singing His praises all day long. Even when life is hard, He is waiting to comfort you with His unfailing love so that gladness will creep over your heart once more.

Father, You are the Author of joy. Thank You so much for Your unfailing love that fills me to the brim. Give me grace and gladness every minute of every day. Amen.

Day 21

BEYOND WORDS...TO THE HEART

And so the Lord says, "These people say they are mine. They honor
me with their lips, but their hearts are far from me. And their
worship of me is nothing but man-made rules learned by rote."

ISAIAH 29:13 NLT

From God's perspective, the actions of our hearts speak louder than our words. And if our worship consists of mindlessly repeating words and going with the flow, we are missing out on connecting with a God who fiercely loves us and desires to be in an unscripted relationship with us.

This verse carries a sobering reminder that God looks beyond the words of our mouths and considers the heart that utters them. Creeds and prayers are familiar ways to connect with God and serve as wonderful reminders of His steadfast character. The next time an opportunity arises to recite from memory, consider how to bring the well-known words to life in a new and fresh understanding—spoken from the heart.

Father, when I read the Bible, I will savor each
word and consider its meaning. And when I pray
a familiar prayer, I will pray from my heart. Amen.

Day 22

ANXIOUS ANTICIPATIONS

*I am not saying this because I am in need, for I have
learned to be content whatever the circumstances.*

PHILIPPIANS 4:11 NIV

Have you ever been so eager for the future that you forgot to be
thankful for the present day?

Humans have a tendency to complain about the problems
and irritations of life. It's much less natural to appreciate the
good things we have—until they're gone. While it's fine to look
forward to the future, let's remember to reflect on all of *today's*
blessings—the large and the small—and appreciate all that we
do have.

*Thank You, Lord, for the beauty of today. Please
remind me when I become preoccupied with the
future and forget to enjoy the present. Amen.*

Day 23

CONFIDENT HOPE

For you have been my hope, Sovereign LORD,
my confidence since my youth.
PSALM 71:5 NIV

Internal clues suggest that the psalmist wrote Psalm 71 during a troublesome time. In the midst of recounting his situation, he asserted that God had been his hope and confidence since his youth. As Paul later outlined in Romans 5, his previous experiences built that hope.

Confidence in the Lord allows us to face disasters without fear (Proverbs 3:25–26), to live in peace (Isaiah 32:17), and to approach God (Ephesians 3:12). In an unpredictable world, we serve an unchanging God who has earned our confidence.

Father, in this ever-changing, fast-paced world, I find
comfort knowing that You never change. My confidence
is in You with a good outcome guaranteed. Amen.

Day 24

WHOLE AND HEALTHY

When Jesus heard this, he told them, "Healthy people don't need
a doctor—sick people do. I have come to call not those who think
they are righteous, but those who know they are sinners."

MARK 2:17 NLT

With Jesus, we never need to pretend to be something we aren't.
We don't need to impress Him with our spiritual maturity and
mental acuity. Instead, we can come to Him honestly, with all
our neediness, admitting just how weak we are. When we do, we
let down the barriers that keep Him out of our hearts. We allow
His grace to make us whole and healthy.

Jesus, help me to resist the temptation to be something
I'm not. Instead, give me a spirit of vulnerability
so that I can receive Your healing grace. Amen.

Day 25

CALL ON HIM IN FAITH

*"Call to me and I will answer you and tell you
great and unsearchable things you do not know."*
JEREMIAH 33:3 NIV

Jeremiah 33:3 teaches that if we pray to God, He will answer us with wisdom. In the King James Version of the Bible, the word *pray* is used more than five hundred times. God wants us to pray. When we call on Him in prayer, we know that He hears us (1 John 5:15).

Proverbs 2:6 (NASB) says, "For the LORD gives wisdom; from His mouth come knowledge and understanding." God knows us fully, and He is able to direct us in wisdom and guide us through the works of His Holy Spirit.

Just as God gave Jeremiah wisdom when he prayed, He will do the same for you if you call on Him in faith (James 1:5–6).

*God, I need Your help. I've sought counsel for my
problem, and I'm still not sure what to do. But You
know! Please, God, guide me with Your wisdom. Amen.*

Day 26

INFINITE AND PERSONAL

*Am I a God at hand, saith the LORD, and not a
God afar off? . . . Do not I fill heaven and earth?*
JEREMIAH 23:23–24 KJV

God says that He is both close at hand and over all there is.
Whether your day is crumbling around you or is the best day you
have ever had, do you see God in it? If the "sky is falling" or the
sun is shining, do you still recognize the One who orders all the
planets and all your days? Whether we see Him or not, God tells
us He is there. And He's here too—in the good times and bad.

*Lord, empower me to trust You when it's hard to remember that You
are near. And help me to live thankfully when times are good. Amen.*

Day 27

EXPECTANT HOPE

*In the morning, LORD, you hear my voice;
in the morning I lay my requests before
you and wait expectantly.*
PSALM 5:3 NIV

God fulfills His side of the bargain to hear our prayers. Then we take off on our merry way, trying to solve our dilemma without Him. We leave His presence without lingering with the Lord to listen and to worship Him in the silence of our hearts. Then later we return with more demands and *gimmes*. God knows our human hearts and understands. He gently waits to hear from us—and He delights when we keep our end of the bargain and linger in His light with hearts full of anticipation and hope.

Dear God, my hope is in You. Thank You for listening to my prayers and knowing exactly what I need. I wait patiently, expectantly, knowing that You will answer me. Amen.

Day 28

SPIRIT OXYGEN

Tell me this one thing: How did you receive the Holy Spirit?
Did you receive the Spirit by following the law? No, you received
the Spirit because you heard the Good News and believed it.

GALATIANS 3:2 NCV

As we share the good news of Christ, we need to take care that we are not preaching the law rather than the love of Christ. The Spirit did not come into your heart through legalism and laws—and He won't reach others through you if that is your focus. Breathe deeply of grace, and let it spread from you to a world that is desperate for the oxygen of the Spirit.

Father, Son, and Holy Spirit, how grateful I am for the good news of the Gospel. Remind me of the grace I have received, and enable me to share it freely with others. Amen.

Day 29

PRAYER SCHEDULE

Seven times a day I praise you for your righteous laws.
PSALM 119:164 NIV

The Bible tells us to pray without ceasing. A fixed-hour prayer ritual is called "praying the hours" or the "daily office." Hearts and minds turn toward God at set times. We make an effort to create a space in our busy lives to praise God and express our gratitude throughout the day.

We can create any kind of prayer schedule. Each stoplight we pass, the ring of the alarm on our watches, or a pause during television commercials can all serve as simple reminders to pray. We can be alert during the day for ways God protects and guides us.

Seven moments a day—to thank the Lord for all the moments of our lives.

Sometimes I forget to pray; busyness gets in the way.
But I can change that! I will set aside specific times
throughout my day to pray and praise You, Lord. Amen.

Day 30

IN THE DETAILS

"When we heard of it, our hearts melted in fear and everyone's courage failed because of you, for the LORD your God is God in heaven above and on the earth below."

JOSHUA 2:11 NIV

Sometimes, when our lives seem to be under siege from the demands of work, bills, family—whatever—finding the work of God amid the strife can be difficult. Even though we acknowledge His power, we may overlook the gentle touches, the small ways in which He makes every day a little easier. Just as the Lord cares for the tiniest bird (Matthew 10:29–31), so He seeks to be a part of every detail in your life. Look for Him there.

Father God, I know You are by my side every day, good or bad, and that You love and care for me. Help me to see Your work in my life and in the lives of my friends and family. Amen.

Day 31

LOVE SONG OF FORGIVENESS

*"In that day," declares the L*ORD*, "you will call me*
'my husband'; you will no longer call me 'my master.'"

Hosea 2:16 niv

God wants *our* hearts. He desires a relationship with us based on love and forgiveness. He enters into a covenant with us, like the marriage between Hosea and Gomer. God is the loving, faithful husband, constantly pursuing us no matter what we do or where we roam. Though it is difficult to grasp how much He loves us, we find hope in His promise. God will keep His commitment to us. His love song to us is forgiveness, and His wedding vow is unconditional love.

Thank You for loving me so fully and unconditionally,
God. I find comfort knowing that as much as any man
on earth could love me, You love me more. Amen.

Day 32

UNCHANGED

*Why am I discouraged? Why is my heart
so sad? I will put my hope in God!*
PSALM 42:5 NLT

Thousands of years ago, the psalmist who wrote these words expressed the same feelings we all have. Some days we just feel blue. The world looks dark, everything seems to be going wrong, and our hearts are sad. Those feelings are part of the human condition. Like the psalmist, we need to remind ourselves that God is unchanged by cloudy skies and gloomy hearts. His grace is always the same, as bright and hopeful as ever.

Heavenly Father, when I am overcome by sadness, help me to see Your light shimmering just beyond the clouds. Thank You for Your grace, which is a bright promise and a great comfort. Amen.

Day 33

PRAYERS OF CONFESSION

"Come now, let us reason together, says the Lord: though your sins are like scarlet, they shall be as white as snow; though they are red like crimson, they shall become like wool."

Isaiah 1:18 RSV

God wanted to hear prayers of repentance, and He wanted that repentance to be followed by action. He commanded: "Cease to do evil, learn to do good" (Isaiah 1:16–17 RSV).

The people were in the habit of living selfishly and trampling on others, but God promised that if they repented, though their sins were like scarlet, every stain would be washed away. The word *scarlet* means "double-dyed" and refers to dipping white garments in scarlet dye twice to make certain that it would not wash out. Yet God said He *would* wash every stain away.

This message is still true for us today: God can forgive the deepest sins and wash us clean, "as white as snow."

I will confess my sins to You, God. I praise You for Your forgiveness. How wonderful You are to forgive even my worst sins and reward me with a clean heart. Amen.

Day 34

MARVELOUS PLANS

Lord, you are my God; I will exalt you and praise
your name, for in perfect faithfulness you have done
wonderful things, things planned long ago.

ISAIAH 25:1 NIV

God has a "promised land" for us all—a marvelous plan for our
lives. Recount and record His faithfulness in your life in the past,
because God has already demonstrated His marvelous plans to you
in so many ways. Then prayerfully anticipate the future journey
with Him. Keep a record of God's marvelous plans in a journal
as He unfolds them day by day. You will find God to be faithful
in the smallest aspects of your life and oh so worthy of your trust.

Oh Lord, help me to recount Your faithfulness,
record Your faithfulness, and trust Your faithfulness
in the future. For You are my God, and You have
done marvelous things, planned long ago. Amen.

Day 35

SEEKING GOD'S PLAN

For we are His workmanship, created in Christ Jesus for good works,
which God prepared beforehand that we should walk in them.

EPHESIANS 2:10 NKJV

How can you know God's plans for your life? First, you should meet with Him in prayer each day and seek His will. Studying the Bible is also important. Often, God speaks to us directly through His Word (Psalm 119:105). Finally, you must have faith that God *will* work out His plan for your life and that His plan is good. Jeremiah 29:11 (NIV) says, "'For I know the plans I have for you,' declares the LORD, 'plans to prosper you and not to harm you, plans to give you hope and a future.'" Are you living in Christ's example and seeking God's plan for your life?

Father, what is Your plan for me? I know that it is good. Reveal it
to me, Lord. Speak to me through prayer and Your Word. Amen.

Day 36

WHAT GOD SHOWS US

The Lord is righteous in everything
he does; he is filled with kindness.
Psalm 145:17 nlt

Did you know that the word *kind* comes from the same root as *kin*? Both words originally had to do with intimate shared relationships like the ones that exist between members of the same family. This is what God shows us: the kindness of a good father, the gentleness of a good mother, the understanding of a brother or sister.

Good Father, thank You for Your kindness and for creating me with a longing to be close to You. May I find rest in Your nearness. Amen.

Day 37
THE VERY BEST

"But if you remain in me and my words remain in you,
you may ask for anything you want, and it will be granted!"

John 15:7 nlt

Wow! Really? Is that true?

As silly as this may sound, there are some who assume that they have license to treat God as a concierge of some kind, who is standing by to rush to fulfill their every request.

As we present our requests to God, we need to realize that He knows what is best for us and that we should never demand "our way." We must not forget the first part of John 15:7 that says, "If you remain in me and my words remain in you." This should clearly tell us that our first desire needs to be that God's will is done.

Since God only wants to give us the very best and He knows how to make that happen, why would we pray for anything else?

Father, I say, "Thy will be done!" You know best. I want what
You want for me, even if it's not what I ask for. Amen.

Day 38

A SHADOW OF THE PAST

"Only Rahab the prostitute and all who are with her in her house shall be spared, because she hid the spies we sent."

JOSHUA 6:17 NIV

Rahab wasn't trapped by her past. It didn't hold her back. She was used by God. Her name has come down to us centuries later because of her bold faith. We all have to deal with a past. But God is able to bring good from a painful past. By the grace and power of God we can make choices in the present that can affect our future. There is transforming power with God. We have hope, no matter what lies behind us.

Holy Spirit, You are always at work. Don't ever stop! Show me a new way, Lord. Help me to make healthier choices for myself and my family. Thank You for Your renewing presence in my life. Amen.

Day 39

RELEASING YOUR
HOLD ON ANXIETY

*Search me, God, and know my heart; test me
and know my anxious thoughts. See if there is any
offensive way in me, and lead me in the way everlasting.*

PSALM 139:23–24 NIV

What is it that weighs you down? Financial issues? An unhealthy
relationship? Your busy schedule? Surrender these misgivings to a
God who wants to take them from you. Ask Him to search your
heart for any and all anxieties, for any and all signs that you have
not truly put your trust in Him. Find the trouble spots in your
life to which you direct most of your thoughts and energy, and
then hand these troubles over to One who can truly address them.
Realize that you are only human and that God is infinitely more
capable of balancing your cares than you are.

*Lord, take from me my anxieties, big and small. May
I remember to give these to You daily so that I will not
find myself distracted by the things of this world.*

Day 40

SING!

*But each day the Lord pours his unfailing
love upon me, and through each night I sing
his songs, praying to God who gives me life.*

PSALM 42:8 NLT

Life itself is a gift of grace. The very blood that flows through
our veins, the beat of our hearts, and the steady hum of our
metabolism—all of that is God's free gift to us, a token of His
constant and unconditional love. When we are so richly loved,
how can we help but sing, even in the darkness?

*Dear Lord, Giver of blessing, Giver of life, as I
experience Your unfailing love each and every day,
teach my heart to sing Your joyful song. Amen.*

Day 41

LISTEN AND FOLLOW

*Know that the LORD is God. It is he who made us, and
we are his; we are his people, the sheep of his pasture.*

PSALM 100:3 NIV

Sheep follow their shepherd and trust in him for provision. Submissive to their masters, they quietly graze the hillsides knowing the shepherd knows best. What a wonderfully relaxing word picture: relying on God's guidance and timing, following His lead.

It is a simple prayer to ask Him to help us give up control, yet not a simple task. In obedience to His Word, we can bow our heads and ask for the Holy Spirit's direction and take our hands from the steering wheel. Then wait. Quietly on our hillsides, not chomping at the bit; hearts "yielded and still." We wait for the still, small voice. This day, resolve to listen and follow.

*Lord, we humbly bow before You and ask for Your
divine guidance. Help us to follow Your plan with
yielded hearts, ever ready to give up control to You. Amen.*

Day 42

CHARM BRACELET

*But the fruit of the Spirit is love, joy, peace,
patience, kindness, goodness, faithfulness, gentleness,
self-control; against such things there is no law.*

GALATIANS 5:22–23 NASB

A charm bracelet is a beautiful way to commemorate milestones
or special events. Consider your spiritual charm bracelet. If you
had a charm to represent your growth in each of the traits from
Galatians 5, how many would you feel comfortable attaching to
your bracelet in representation of that achievement? Ask your
Father which areas in your Christian walk need the most growth.
Do you need to develop those traits more before you feel com-
fortable donning your bracelet?

*Lord, please show me which milestones of Christian
living I need to focus on in order to have the full
markings of the Holy Spirit in my life. Please help me to
grow into the Christian woman You call me to be. Amen.*

Day 43
STANDING STILL

"The Lord will fight for you; you need only to be still."
Exodus 14:14 NIV

Moses commanded the Israelites to stop panicking and stand still. Then God held back the waters of the Red Sea, and the Israelites were able to walk across on dry ground! When the Egyptians tried to follow them, the waters rushed in and drowned them all. Sometimes when we stress and panic, we rack our brains trying to figure out solutions to our problems; and instead of standing still and praying to God, we become even more panicked. Moses' words still apply to us today. When we face our fears, we should be still, trusting in God and relying on Him to bring us through the struggle.

Dear Lord, please teach me to be still and to trust in You.
Thank You for Your constant faithfulness. Amen.

Day 44

THRIVE!

Those who trust in their riches will fall,
but the righteous will thrive like a green leaf.

PROVERBS 11:28 NIV

Money seems so important in our world. Many things we want depend on money—that remodeling project we're hoping to do, the Christmas gifts we want to give, the vacation we hope to take, and the new car we want to drive. There's nothing wrong with any of those things, but our enjoyment of them will always be fleeting. Only God's daily grace makes us truly grow and thrive.

Father, remind me that while caring for my family,
making money, and preparing for my future are
good things, they are not my identity. Help me to
find my purpose, my worth, in You. Amen.

Day 45

CALL ON ME

"Call on me in the day of trouble;
I will deliver you, and you will honor me."
PSALM 50:15 NIV

When God says He wants us to call Him, He means it. He must lean closer, bending His ear, waiting, longing for the sound of His name coming from our lips. He stands ready to deliver us from our troubles or at least to carry us through them safely.

While He doesn't always choose to fix things with a snap of His fingers, we can be assured that He will see us through to the other side of our troubles by a smoother path than we'd travel without Him. He's waiting to help us. All we have to do is call.

Dear Father, I'm so glad I can call on You
anytime, with any kind of trouble. Amen.

Day 46

THE SECRET OF SERENDIPITY

A happy heart makes the face cheerful.
PROVERBS 15:13 NIV

Can you remember the last time you laughed in wild abandon? Better yet, when was the last time you did something fun, outrageous, or out of the ordinary? Perhaps it is an activity you haven't done since you were a child, like slip down a waterslide, strap on a pair of ice skates, or pitch a tent and camp overnight. A happy heart turns life's situations into opportunities for fun. When we seek innocent pleasures, we glean the benefits of a happy heart. So try a bit of whimsy just for fun. And rediscover the secret of serendipity.

Dear Lord, because of You, I have a happy heart. Lead me to do something fun and spontaneous today! Amen.

Day 47

ROCK SOLID

"Therefore everyone who hears these words of mine and puts them into practice is like a wise man who built his house on the rock. The rain came down, the streams rose, and the winds blew and beat against that house; yet it did not fall, because it had its foundation on the rock."

Matthew 7:24–25 niv

Prepare for tomorrow's storms by laying a solid foundation today. Rain and wind are guaranteed to come. It is only a matter of time. We need to be ready. When our foundation is the Rock, Jesus Christ, we will find ourselves still standing when the storm has passed. Rain will come. Winds will blow and beat hard against us. Yet, when our hope is in the Lord, we will not be destroyed. We will remain steadfast because our feet have been firmly planted. Stand upon the Rock today so that your tomorrows will be secure.

Dear Lord, help me build my foundation today upon You so I can remain steadfast in the storms of life. Amen.

Day 48
GET ABOVE IT ALL

Set your mind and keep focused habitually on the things above
[the heavenly things], not on things that are on the earth.
COLOSSIANS 3:2 AMP

Sometimes the most difficult challenges you face play out in your
head—where a struggle to control the outcome and work out the
details of life can consume you. Once removed—far away from the
details—you can see things from a higher perspective. Close your
eyes and push out the thoughts that try to grab you and keep you
tied to the things of the world. Reach out to God and let your spirit
soar. Give your concerns to Him and let Him work out the details.
Rest in Him and He'll carry you above it all, every step of the way.

God, You are far above any detail of life that concerns me. Help me
to trust You today for answers to those things that seem to bring
me down. I purposefully set my heart and mind on You today.

Day 49
PRAY INSTEAD OF PLOTTING

*"Pray that the Lord your God will show
us what to do and where to go."*
Jeremiah 42:3 nlt

However bleak your situation seems, God hasn't forgotten you. Philippians 4:6–7 (NLT) says, "Don't worry about anything; instead, pray about everything. Tell God what you need, and thank him for all he has done. Then you will experience God's peace, which exceeds anything we can understand. His peace will guard your hearts and minds as you live in Christ Jesus."

Jeremiah 42:3 echoes this statement. It urges believers to pray for guidance instead of setting out with a preconceived notion of how the day (or month or decade) will turn out.

When you begin to worry that you don't have what it takes to meet life's demands, remember that you don't have to—because God does.

*Jesus, thank You for Your presence and the peace You so freely give.
Help me to pray before I worry, categorize, or strategize. Amen.*

Day 50

THE WHITE KNIGHT

Then I will rejoice in the LORD.
I will be glad because he rescues me.
PSALM 35:9 NLT

We're all waiting for someone to rescue us. We wait and wait and wait. . . The truth is God doesn't want you to exist in a perpetual state of waiting. Live your life—your whole life—by seeking daily joy in the Savior of your soul, Jesus Christ. And here's the best news of all: He's already done the rescuing by dying on the cross for our sins! He's the *true* white knight who secured your eternity in heaven. Stop waiting; seek His face today!

Jesus, I praise You because You are the Rescuer of my soul.
Remind me of this fact when I'm looking for relief in
other people and places. You take care of my present and
eternal needs, and for that I am grateful. Amen.

Day 51
COMPLETED WORK

The LORD will perfect that which concerns me;
Your mercy, O LORD, endures forever;
do not forsake the works of Your hands.
PSALM 138:8 NKJV

The psalmist offers hope when he tells us the Lord will complete things that concern us. We are the work of His hands and He has enduring mercy toward our failures. He is as active in our sanctification as He is in our salvation. Philippians 1:6 (NKJV) says, "Being confident of this very thing, that He who has begun a good work in you will complete it until the day of Jesus Christ." The power to change or to see difficult things through to the end comes from the Lord who promises to complete the work He begins.

Lord, remind me of these word when I am discouraged by my
lack of progress. Help me remember Your eternal love and
mercy to me. Give me confidence that You will complete me.

Day 52
CHOSEN

"I have chosen you and have not rejected you."
ISAIAH 41:9 NIV

The Lord doesn't dump us when we don't measure up. And He doesn't choose us one minute only to reject us a week later. We need not fear being deserted by our loving Father. He doesn't accept or reject us based on any arbitrary standards. He loves us with an everlasting love (Jeremiah 31:3). By His own mercy and design, "he hath made us accepted in the beloved" (Ephesians 1:6 KJV).

*Father, thank You that I don't need
to fear Your rejection of me. Amen.*

Day 53

HANNAH'S PRAYER

"The eyes of the LORD search the whole earth in order to strengthen those whose hearts are fully committed to him."

2 CHRONICLES 16:9 NLT

Hannah was barren. She prayed before God with a broken heart and promised God that if He gave her a child, she would commit him to the Lord all the days of his life. God heard and answered her prayer. God granted Hannah a male child whom she named Samuel. She only had Samuel for a short time before she took him to Eli, the priest. Samuel was not an ordinary child. He heard the voice of God at a very young age. He grew up to become a judge and prophet that could not be matched in all of Israel's history.

God is looking for ordinary men and women whose prayers reflect hearts completely committed to Him. He found such commitment in Hannah, and He answered her prayer.

Father, may my prayers reflect a deep commitment to You, and may all that I ask for be for Your kingdom and not for my own glory. Amen.

Day 54

A COMFORTABLE PLACE

*Don't you realize that your body is the temple
of the Holy Spirit, who lives in you and was
given to you by God? You do not belong to yourself.*

1 CORINTHIANS 6:19 NLT

We take the time to make our homes comfortable and beautiful
when we know visitors are coming. In the same way, we ought to
prepare our hearts for the Holy Spirit, who lives inside of us. We
should daily ask God to help us clean up the junk in our hearts.
We should take special care to tune up our bodies through exer-
cise, eating healthful foods, and dressing attractively and modestly.
Our bodies belong to God. Taking care of ourselves shows others
that we honor God enough to respect and use wisely what He
has given us.

*Dear Lord, thank You for letting me belong to You.
May my body be a comfortable place for You. Amen.*

Day 55
RESCUED

God rescued us from dead-end alleys and dark dun-
geons. He's set us up in the kingdom of the Son he loves so
much, the Son who got us out of the pit we were in, got
rid of the sins we were doomed to keep repeating.
Colossians 1:13–14 msg

The message of the Gospel doesn't leave us trapped in our sin and misery without hope. God sent the Rescuer, Christ, who plucked us out of the dungeons of despair and brought us into His kingdom of light and strength to overcome the dragons of sin. It's by the Father's grace that we are not stuck in our habitual ruts and dead-end alleys, living without purpose and fulfillment. We walk in His kingdom—a kingdom that goes counter to the world's ideas. We are out of the pit, striding confidently in Him, enjoying life to its fullest.

Glory to You, Jesus! You have rescued me from the pit
and lifted me to Your kingdom of real life and victory.
Help me to walk in that fact today. Amen.

Day 56

LIVING A COMPLETE LIFE

*It is a good thing to receive wealth from God
and the good health to enjoy it.*
ECCLESIASTES 5:19 NLT

God has promised to supply all your needs, but it takes action on your part. Seeking wisdom for your situation and asking God to direct you in the right decisions will help you find a well-balanced life that will produce success, coupled with the health to enjoy it. It may be as simple as realizing a vacation is exactly what you need, instead of working throughout the year and taking your vacation in cash to pay for new bedroom furniture. Know when to press forward and when to stop and enjoy the life God has given you for His good pleasure—and yours!

*Lord, I ask for Your wisdom to help me balance my life
so I can be complete in every area of my life. Amen.*

Day 57

KEEP TALKING

The LORD is near to all who call on him,
to all who call on him in truth.

PSALM 145:18 NIV

When we call on God, no matter our circumstances, we become close to Him. He sees our hearts, He has compassion on us, and He longs to pull us into His arms and hold us there. When we call on Him, when we spend time talking to Him and telling Him what's on our minds, we strengthen our relationship with Him. We get *close* to Him.

When we feel far from God, sometimes the last thing we want to do is talk to Him. But it is through honest, heartfelt conversation, however one-sided it may seem to us, that we draw into God's presence. When we feel far from God, we need to keep talking. He's there.

Dear Father, thank You for Your promise to listen to me.
I love You, I need You, and I want to be close to You. Amen.

Day 58

WHO HELPS THE HELPER?

*The LORD is my strength and my shield; my heart trusted
in him, and I am helped: therefore my heart greatly
rejoiceth; and with my song will I praise him.*

PSALM 28:7 KJV

Helping can be exhausting. The needs of young children, teens,
grandchildren, aging parents, our neighbors, and fellow church
members—the list is never ending—can stretch us until we're
ready to snap. And then we find that *we* need help. Who helps the
helper? The Lord does. When we are weak, He is strong. When
we are vulnerable, He is our Shield. When we can no longer trust
in our own resources, we can trust in Him. He is always there,
ready to help. Rejoice in Him, praise His name, and you will find
the strength to go on.

*Father, I'm worn out. I can't care for all the people and
needs You bring into my life by myself. I need Your strength.
Thank You for being my Helper and my Shield. Amen.*

Day 59

A MATTER OF PRIORITIES

*To everything there is a season,
a time for every purpose under heaven.*
ECCLESIASTES 3:1 NKJV

Only one thing in our lives never changes: God. When our world swirls and threatens to shift out of control, we can know that God is never surprised, never caught off guard by anything that happens. Just as He guided David through dark nights and Joseph through his time in prison, God can show us a secure way through any difficulty. He can turn the roughest times to good. Just as He supported His servants in times past, He will always be with us, watching and loving.

*Lord, help me remember Your love and guidance
when my life turns upside down. Grant me
wisdom for the journey and hope for the future. Amen.*

Day 60

HEALED PAST

*"All their past sins will be forgotten, and they will
live because of the righteous things they have done."*
 EZEKIEL 18:22 NLT

We have the feeling that we can't do anything about the past. We
think all our mistakes are back there behind us, carved in stone.
But God's creative power is amazing, and His grace can heal even
the past. Yesterday's sins are pulled out like weeds, while the good
things we have done are watered so that they grow and flourish
into the present. Give your past to God. His grace is big enough
to bring healing even to your worst memories.

*Father, how grateful I am that my past is forgiven and
that I am free! Help me to continue to trust You to
keep bringing righteousness into my life. Amen.*

Day 61
WHEN YOU CAN'T PRAY

*And the Holy Spirit helps us in our weakness. For example, we don't
know what God wants us to pray for. But the Holy Spirit prays
for us with groanings that cannot be expressed in words. And the
Father who knows all hearts knows what the Spirit is saying, for
the Spirit pleads for us believers in harmony with God's own will.*

ROMANS 8:26–27 NLT

Sometimes we literally cannot pray. The Holy Spirit takes over on
such occasions. Go before God; enter into His presence in a quiet
spot where there will not be interruptions. And just be still before
the Lord. When your heart is broken, the Holy Spirit will inter-
cede for you. When you have lost someone or something precious,
the Holy Spirit will go before the Father on your behalf. When
you are weak, the Comforter will ask the Father to strengthen you.
When you are confused and anxious, the Counselor will seek God's
best for you. You are not alone. Christ sent a Comforter, a Coun-
selor, the Holy Ghost, the Spirit of Truth. When you don't know
what to pray, the Bible promises that the Spirit has you covered.

*Father, please hear the groaning of the Holy Spirit,
who intercedes on my behalf before Your throne. Amen.*

Day 62

NO MORE STING

O death, where is thy sting?
O grave, where is thy victory?
1 CORINTHIANS 15:55 KJV

We have a choice to make. We can either live life in fear or live life by faith. Fear and faith cannot coexist. Jesus Christ has conquered our greatest fear—death. He rose victorious and has given us eternal life through faith. Knowing this truth enables us to courageously face our fears. There is no fear that cannot be conquered by faith. Let's not panic but trust the Lord instead. Let's live by faith and experience the victory that has been given to us through Jesus Christ our Lord.

Lord, You alone know my fears. Help me to trust You more.
May I walk in the victory that You have purchased for me. Amen.

Day 63
REMEMBER THIS

Keep your eyes on Jesus, who both
began and finished this race we're in.
HEBREWS 12:2 MSG

When our heads are spinning and tears are flowing, there is only one thing to remember: focus on Jesus. He will never leave you nor forsake you. When you focus on Him, His presence envelops you. Where there is despair, He imparts hope. Where there is fear, He imparts faith. Where there is worry, He imparts peace. He will lead you on the right path and grant you wisdom for the journey. When the unexpected trials of life come upon you, remember this: focus on Jesus.

Dear Lord, I thank You that nothing takes You by
surprise. When I am engulfed in the uncertainties
of life, help me remember to focus on You. Amen.

Day 64

CHANGING OUR PERSPECTIVE

Turn my eyes away from worthless things;
preserve my life according to your word.
PSALM 119:37 NIV

The book of Psalms offers hundreds of verses that can easily become sentence prayers. "Turn my eyes away from worthless things" whispered before heading out to shop, turning on the television, or picking up a magazine can turn those experiences into opportunities to see God's hand at work in our lives. He can change our perspective. He will show us what has value for us. He can even change our appetites, causing us to desire the very things He wants for us. When we pray this prayer, we are asking God to show us what He wants for us. He knows us and loves us more than we know and love ourselves. We can trust His love and goodness to provide for our needs.

Father, imprint this scripture in my mind today.
In moments of need, help me remember to pray
this prayer and to relinquish my desires to You.

Day 65

WHO GOD HEARS

*The LORD is far from the wicked, but he
hears the prayers of the righteous.*
PROVERBS 15:29 NLT

When the righteous call God's name, He hears. Though none of us are righteous on our own, we can claim righteousness through Jesus Christ. He alone is righteous, and He covers us like a cloak. When we call on God, He sees the righteousness that covers us through Christ and recognizes us as His children. He leans over and listens carefully to our words because we belong to Him. He loves us.

Next time it seems like God isn't listening, perhaps we should examine our hearts. Have we pushed God away?

Have we accepted the price His Son, Jesus Christ, paid on our behalf? If not, we can't claim righteousness. If we have, we can trust that He's never far away. He hears us.

*Dear Father, thank You for making me
righteous through Your Son, Jesus. Amen.*

Day 66

A BETTER OFFER

*"So in everything, do to others what
you would have them do to you."*
Matthew 7:12 niv

Jesus took responsibilities, commitments, and obligations seriously. In fact, Jesus said, "All you need to say is simply 'Yes' or 'No'; anything beyond this comes from the evil one" (Matthew 5:37 NIV). Satan desires for us to be stressed out, overcommitted, and not able to do anything well. Satan delights when we treat others in an unkind, offensive manner. However, God, upon request, will help us prioritize our commitments so that our "yes" is "yes" and our "no" is "no." Then in everything we do, we are liberated to do to others as we would have them do to us.

*Lord, please prioritize my commitments to
enable me in everything to do to others as
I would desire for them to do to me. Amen.*

Day 67

WHAT RICHES DO YOU POSSESS?

Command those who are rich. . .not to be arrogant nor to put their hope in wealth, which is so uncertain, but to put their hope in God, who richly provides us with everything for our enjoyment.

1 TIMOTHY 6:17 NIV

God desires to bless us with possessions we can enjoy. But it displeases Him when His children strain to attain riches in a worldly manner out of pride or a compulsion to flaunt. Riches are uncertain, but faith in God to meet our provisions is indicative of the pure in heart. Pride diminishes the capacity for humility and trust in God. We are rich indeed when our hope and faith are not in what we have but in whom we trust.

Heavenly Father, my hope is in You for my needs and my desires. I surrender any compulsion to attain earthly wealth; rather, may I be rich in godliness and righteousness. Amen.

Day 68

VALUABLE

*Better to be patient than powerful; better to
have self-control than to conquer a city.*

PROVERBS 16:32 NLT

Our world values visible power. We appreciate things like prestige
and skill, wealth and influence. But God looks at things differ-
ently. From His perspective, the quiet, easily overlooked quality
of patience is far more valuable than any worldly power. Patience
makes room for others' needs and brokenness. Patience creates a
space in our lives for God's grace to flow through us.

*Lord, when I come to Your Word, I am constantly reminded
that Your wisdom is not the world's wisdom. Give me Your
perspective. Draw me toward the practice of patience. Amen.*

Day 69

THE GIFT OF PRAYER

*First of all, then, I urge that petitions (specific requests),
prayers, intercessions (prayers for others) and thanksgivings be
offered on behalf of all people. . . . This [kind of praying] is good
and acceptable and pleasing in the sight of God our Savior.*

1 Timothy 2:1, 3 AMP

Perhaps the absolute greatest gift one person can give to another doesn't come in a box. It can't be wrapped or presented formally, but instead it is the words spoken to God for someone—the gift of prayer.

When we pray for others, we ask God to intervene and to make Himself known to them. We can pray for God's plan and purpose in their lives. We can ask God to bless them or protect them. You can share with them that you are praying for them or do it privately without their knowledge. Who would God have you give the gift of prayer to today?

*Lord, thank You for bringing people to my heart and mind
who need prayer. Help me to pray for the things that they
need from You in their lives. Show me how to give the gift
of prayer to those You would have me pray for. Amen.*

Day 70

ONE STEP AT A TIME

With your help I can advance against a troop;
with my God I can scale a wall.

PSALM 18:29 NIV

We often become discouraged when we face a mountain-sized task. Whether it's weight loss or a graduate degree or our income taxes, some things just seem impossible. And they often *can't* be done—not all at once. Tasks like these are best faced one step at a time. One pound at a time. Chipping away instead of moving the whole mountain at once. With patience, perseverance, and God's help, your goals may be more attainable than you think.

Dear Father, the task before me seems impossible.
However, I know I can do it with Your help. I pray
that I will trust You every step of the way. Amen.

Day 71

PERSEVERING THROUGH ADVERSITY

"But if it is from God, you will not be able to stop these men;
you will only find yourselves fighting against God." His speech
persuaded them. They called the apostles in and had them flogged.
Then they ordered them not to speak in the name of Jesus, and let
them go. The apostles left the Sanhedrin, rejoicing because they
had been counted worthy of suffering disgrace for the Name.

ACTS 5:39–41 NIV

Scripture overflows with stories of God's beloved children undergoing extreme hardships. Just because we have faith, hope, and trust in the Lord does not mean that life will be easy. Instead, God's love for us means that He will provide a way *through*, not around, adversity, resulting in His greater glory. Everyone experiences tough times. The goal, however, is not to find relief. It is to live in a way that shows how well we love and trust the Lord.

Father God, I know that no matter how troubled
my life is, You can provide me a way to persevere.
Help me to trust Your guidance and love. Amen.

Day 72

AN ALL-THE-TIME THING!

*Pray diligently. Stay alert, with your
eyes wide open in gratitude.*

<small>COLOSSIANS 4:2 MSG</small>

Prayer is not a sometimes thing. It's an all-the-time thing! We need to pray every day, being careful to keep the lines of communication open between God and ourselves all through the day, moment by moment. When we make prayer a habit, we won't miss the many gifts of grace that come our way. And we won't forget to notice when God answers our prayers.

*Father, although it's important to set aside specific
time for prayer, I am reminded of the value of
being in constant communication with You—
my good Father, my Companion. Amen.*

Day 73

A WONDERFUL COMPANION

Pray in the Spirit at all times with all kinds of prayers.
EPHESIANS 6:18 NCV

God wants to be included in our days. He wants to walk and talk with us each moment. Imagine if we traveled through the day with our children or our spouse, but we only spoke to them between 6:15 and 6:45 a.m.! Of course we'd never do that to the people we care about. God doesn't want us to do that to Him either.

God wants to travel the journey with us. He's a wonderful Companion, offering wisdom and comfort for every aspect of our lives. But He can only do that if we let Him into our schedules, every minute of every day.

Dear Father, thank You for always being there to listen.
Remind me to talk to You about everything, all the time. Amen.

Day 74

STOP AND CONSIDER

"Listen to this, Job; stop and consider God's wonders. Do you know how God controls the clouds and makes his lightning flash? Do you know how the clouds hang poised, those wonders of him who has perfect knowledge?"

JOB 37:14–16 NIV

"Stop and consider My wonders," God told Job. Then He pointed to ordinary observations of the natural world surrounding Job—the clouds that hung poised in the sky, the flashes of lightning. "Not so very ordinary" was God's lesson. Maybe He was trying to remind us that there is no such thing as ordinary. Let's open our eyes and see the wonders around us.

Oh Father, teach me to stop and consider the ordinary moments of my life as reminders of You. Help me not to overlook Your daily care and provisions that surround my day. Amen.

Day 75

DAYBREAK

"As your days, so shall your strength be."
DEUTERONOMY 33:25 NKJV

There are times in life when we feel that the night season we're facing will last forever and a new morning will never come. For those particularly dark seasons of your life, you don't have to look to the east to find the morning star but instead find that morning star in your heart. Allow the hope of God's goodness and love to rekindle faith. With the passing of the night, gather your strength and courage. A new day is dawning and with it new strength for the journey forward. All that God has promised will be fulfilled.

*Heavenly Father, help me to hold tightly
to faith, knowing in this situation that
daybreak is on its way. Amen.*

Day 76

RIGHT NOW

For God says, "At just the right time, I heard you. On the day of salvation, I helped you." Indeed, the "right time" is now. Today is the day of salvation.

2 CORINTHIANS 6:2 NLT

God always meets us right now, in the present moment. We don't need to waste our time looking over our shoulders at the past, and we don't have to feel as though we need to reach some future moment before we can truly touch God. He is here now. Today, this very moment, is full of His grace.

Lord, make me mindful of Your presence right now, in this very minute. You have redeemed my past, and You hold my future in Your hands. This moment is the one I must cling to. Amen.

Day 77

BEFORE YOU ASK

*"Seek the Kingdom of God above all else, and live
righteously, and he will give you everything you need."*
MATTHEW 6:33 NLT

In the Lord's Prayer, Jesus teaches His followers how to pray. He begins, "Our Father in heaven, may your name be kept holy. May your Kingdom come soon. May your will be done on earth, as it is in heaven" (Matthew 6:9–10 NLT). First, Jesus honors God's holiness. Next, He shows faith in God's promise of reigning over the earth and redeeming His people. Then He accepts God's perfect will. Praise, faith, and acceptance come before asking. Jesus reminds believers to honor God first, put God's will second, and pray for their own needs third. His prayer begins with God and ends with Him: "For thine is the kingdom, and the power, and the glory, for ever. Amen" (Matthew 6:13 KJV).

Bring your requests to God. Ask specifically and confidently, but remember Jesus' model—put God first in your prayers.

*Dear God, I praise You. My faith rests in You, and I
accept whatever Your will is for my life. Amen.*

Day 78

WHY ME?

*I am Alpha and Omega, the beginning and the ending,
saith the Lord, which is, and which was,
and which is to come, the Almighty.*

Revelation 1:8 kjv

When God spoke our world into existence, He called into being a certain reality, knowing then everything that ever was to happen—and everyone who ever was to be. That you exist now is cause for rejoicing! God made *you* to fellowship with Him! If that fellowship demands trials for a season, rejoice that God thinks you worthy to share in the sufferings of Christ—and, eventually, in His glory. Praise His holy name!

*Father, I thank You for giving me this difficult
time in my life. Shine through all my trials
today. I want You to get the glory. Amen.*

Day 79

A FRESH NEW HARVEST

Do not rejoice over me, my enemy; when I fall, I will arise;
when I sit in darkness, the LORD will be a light to me.

MICAH 7:8 NKJV

The enemy of your soul wants you to consider each failure and dwell on the past, fully intending to rob you of your future. But God wants you to take that seed of hope that seems to have died and bury it in His garden of truth—trusting Him for a new harvest of goodness and mercy. Once you have buried that seed deep in the ground of God's love, it will grow and become a part of His destiny for your life.

Lord, help me not to focus on the past but
to look to You every step of the way. Amen.

Day 80
A QUIET PACE

"Teach me, and I will be quiet.
Show me where I have been wrong."

Job 6:24 NCV

Do you ever feel as though you simply can't sit still? That your thoughts are swirling so fast that you can't stop them? That you're so busy, so stressed, so hurried that you have to run, run, run? Take a breath. Open your heart to God. Allow Him to quiet your frantic mind. Ask Him to show you how you can begin again, this time walking to the quiet pace of His grace.

Father, quietness does not always come easily. The frenetic pace of this world sucks the peace from my life. Calm my mind, Lord. Calm my heart. I want to walk in Your amazing grace. Amen.

Day 81
ASK IN FAITH

But when you ask God, you must believe and not doubt. Anyone who doubts is like a wave in the sea, blown up and down by the wind.

JAMES 1:6 NCV

What does it mean to ask God for something *in faith*? Does it mean we believe that He *can* grant our requests? That He *will* grant our requests? Exactly what is required to prove our faith?

There is no secret ingredient that makes all our longings come to fruition. The secret ingredient, if there is one, is faith that God is who He says He is. It's faith that God is good and will use our circumstances to bring about His purpose and high calling in our lives and in the world.

When we don't get the answers we want from God, it's okay to feel disappointed. He understands. But we must never doubt His goodness or His motives. We must stand firm in our belief that God's love for us will never change.

Dear Father, I know that You are good and that You love me. I know Your love for me will never change, even when my circumstances are hard. Help me cling to Your love, even when You don't give the answers I want. Amen.

Day 82

FOLLOW THE LORD'S FOOTSTEPS

Then He said to them, "Follow Me,
and I will make you fishers of men."
MATTHEW 4:19 NKJV

Jesus asked His disciples to follow Him, and He asks us to do the same. Following Jesus requires staying right on His heels. We need to be close enough to hear His whisper. Stay close to His heart by opening the Bible daily. Allow His Word to speak to your heart and give you direction. Throughout the day, offer up prayers for guidance and wisdom. Keep in step with Him, and His close presence will bless you beyond measure.

Dear Lord, grant me the desire to follow You.
Help me not to run ahead or lag behind. Amen.

Day 83

RELEASE THE MUSIC WITHIN

*Those who are wise will find a
time and a way to do what is right.*
Ecclesiastes 8:5 nlt

It has been said that many people go to their graves with their music still in them. Do you carry a song within your heart, waiting to be heard? Whether we are eight or eighty, it is never too late to surrender our hopes and dreams to God. A wise woman trusts that God will help her find the time and manner in which to use her talents for His glory as she seeks His direction. Let the music begin.

Dear Lord, my music is fading against the constant beat of a busy pace. I surrender my gifts to You and pray for the time and manner in which I can use those gifts to touch my world. Amen.

Day 84

FROM THE INSIDE OUT

*Take on an entirely new way of life—a God-fashioned life,
a life renewed from the inside and working itself into your
conduct as God accurately reproduces his character in you.*

EPHESIANS 4:24 MSG

At the end of a long week, we sometimes feel tired and drained.
We need to use feelings like that as wake-up calls, reminders that
we need to open ourselves anew to God's Spirit so that He can
renew us from the inside out. Grace has the power to change our
hearts and minds, filling us with new energy to follow Jesus.

*Lord, the world says change comes from the outside. Your Word
says that true transformation comes from the inside. Meet
me there—on the inside—and make me like You. Amen.*

Day 85

BEST START TO YOUR DAY

In the morning, LORD, you hear my voice;
in the morning I lay my requests before
you and wait expectantly.

PSALM 5:3 NIV

How can you start your day with God even if you haven't gotten up hours earlier for devotions? As you wake up in the morning, thank the Lord for a new day. Ask Him to control your thoughts and attitude as you make the bed. Thank Him for providing for you as you toast your bagel. Ask that your self-image be based on your relationship with Christ as you get dressed and brush your teeth. Continue to pray as you drive to work or school. Spend time in His Word throughout the day. End your day by thanking Him for His love and faithfulness.

God wants a constant relationship with you, and He is available and waiting to do life with you twenty-four hours a day.

Dear Lord, thank You for the gift of a new day. Help me
be aware of Your constant presence in my life. Amen.

Day 86

ANNUAL OR PERENNIAL?

*They are like trees planted along the riverbank,
bearing fruit each season. Their leaves never
wither, and they prosper in all they do.*

PSALM 1:3 NLT

Annuals or perennials? Each has its advantages. Annuals are inexpensive, provide instant gratification, and keep boredom from setting in. Perennials require an initial investment but, when properly tended, faithfully provide beauty year after year—long after the annuals have dried up and withered away. Perennials are designed for the long haul—not just short-term enjoyment but also long-term beauty. The application to our lives is twofold. First, be a perennial—long lasting, enduring, slow growing, steady, and faithful. Second, don't be discouraged by your inevitable dormant seasons. Tend to your soul, and it will reward you with years of lush blossoms.

Father, be the Gardener of my soul. Amen.

Day 87

JONAH'S PRAYER

"When my life was ebbing away, I remembered you,
LORD, and my prayer rose to you, to your holy temple."

JONAH 2:7 NIV

In Jonah's great prayer from the belly of the fish, we read these words: *"But you, LORD my God, brought my life up from the pit"* (Jonah 2:6 NIV). When Jonah reached a point of desperation, he realized that God was his only hope. Have you been there? Not in the belly of a great fish but in a place where you are made keenly aware that it is time to turn back to God? God loves His children and always stands ready to receive us when we need a second chance.

Father, like Jonah I sometimes think my own ways
are better than Yours. Help me to be mindful that
Your ways are always good and right. Amen.

Day 88

TAKE A BREAK

*"Only in returning to me and
resting in me will you be saved."*
Isaiah 30:15 NLT

Some days you try everything you can think of to save yourself,
but no matter how hard you try, you fail again and again. You fall
on your face and embarrass yourself. You hurt the people around
you. You make mistakes, and nothing whatsoever seems to go right.
When that happens, it's time to take a break. You need to stop
trying so hard. Throw yourself in God's arms. Rest on His grace,
knowing that He will save you.

*Father, sometimes I feel so unsure of myself. Help me to
relax, to rest in Your arms, and to remember that You are
my good Teacher, my Support, and my Comfort. Amen.*

Day 89

OUR PRAYER CALLING

Then she [Anna] lived as a widow to the age of eighty-four.
She never left the Temple but stayed there day and
night, worshiping God with fasting and prayer.
LUKE 2:37 NLT

Have you ever felt useless to the kingdom of God? Do you think
you have little to offer, so you offer little? Consider the eighty-
four-year-old widow Anna. She stayed at the temple worshipping
God through prayer and fasting. That was her calling, and she was
committed to prayer until the Lord ushered her home.

We need not pray and fast like this dedicated woman did. (In
fact, for health reasons, fasting is not always an option.) Yet we
are all called to pray. We can pray right where we are, regardless of
our age, circumstances, or surroundings. Like Anna, it's our calling.

Lord, please remind me of the calling of prayer
on my life, despite my circumstances. Amen.

Day 90
FAULTLESS

*To him who is able to keep you from stumbling and to present you
before his glorious presence without fault and with great joy.*

JUDE 1:24 NIV

Jesus loves us so much despite our shortcomings. He is the One
who can keep us from falling—who can present us faultless before
the Father. Because of this we can have our joy restored no matter
what. Whether we have done wrong and denied it or have been
falsely accused, we can come into His presence to be restored and
lifted up. Let us keep our eyes on Him instead of on our need to
justify ourselves to God or others.

*Thank You, Jesus, for Your cleansing love and for
the joy we can find in Your presence. Amen.*

Day 91
ENCOURAGE ONE ANOTHER

*Therefore encourage one another and build
each other up, just as in fact you are doing.*
1 THESSALONIANS 5:11 NIV

Encouragement is more than words. It is also valuing, being tolerant
of, serving, and praying for one another. It is looking for what is
good and strong in a person and celebrating it. Encouragement
means sincerely forgiving and asking for forgiveness, recognizing
someone's weaknesses and holding out a helping hand, giving
humbly while building someone up, helping others to hope in
the Lord, and praying that God will encourage them in ways that
you cannot.

Whom will you encourage today?

*Heavenly Father, open my eyes to those who need
encouragement. Show me how I can help. Amen.*

Day 92

OUTSIDE TIME'S STREAM

*Your throne, O LORD, has stood from time immemo-
rial. You yourself are from the everlasting past.*

PSALM 93:2 NLT

If you think of time as a fast-moving river, then we are creatures caught in its stream. Life keeps slipping away from us like water between our fingers. But God is outside time's stream. He holds our past safely in His hands, and His grace is permanent and unshakable. His love is the lifesaver to which we cling in the midst of time's wild waves.

*God, when I try to understand words like immemorial and
everlasting, I am in awe. I cannot begin to comprehend Your
bigness. Give me Your perspective. Help me to trust You. Amen.*

Day 93

GOD'S GOOD AND PERFECT WILL

For this reason, since the day we heard about you,
we have not stopped praying for you. We continually ask
God to fill you with the knowledge of his will through all
the wisdom and understanding that the Spirit gives.

COLOSSIANS 1:9 NIV

The apostle Paul reminded the Colossians that he was continuously praying for them to be filled with the knowledge of God's will. Christians have received the Holy Spirit as their Counselor and Guide. Those who do not have a personal relationship with Christ are lacking the Spirit, and thus, they are not able to discern God's will for their lives. Always take advantage of the wonderful gift that you have been given. If you have accepted Christ as your Savior, you also have the Spirit. One of the greatest things about the Holy Spirit is that He helps us to distinguish God's call on our life from the other voices of the world. Pray that God will reveal His good and perfect will for your life.

God, help me to draw upon the wonderful resources
that I have as a Christian. Help me, through the
power of the Holy Spirit, to know Your will. Amen.

Day 94

JUST HALF A CUP

*"I am coming to you now, but I say these things
while I am still in the world, so that they may have
the full measure of my joy within them."*

JOHN 17:13 NIV

Our heavenly Father longs to bestow His richest blessings and wisdom on us. He loves us, so He desires to fill our cup to overflowing with the things that He knows will bring us pleasure and growth. Do you tell Him to stop pouring when your cup is only half-full? You may not even realize it, but perhaps your actions dictate that your cup remains half-empty. Seek a full cup, and enjoy the full measure of the joy of the Lord.

*Dear Jesus, forgive me for not accepting the fullness of
Your blessings and Your joy. Help me to see the ways that
I prevent my cup from being filled to overflowing. Thank
You for wanting me to have the fullness of Your joy. Amen.*

Day 95

LINKING HEARTS WITH GOD

"You will receive power when the Holy Spirit comes on you;
and you will be my witnesses. . .to the ends of the earth."

ACTS 1:8 NIV

God knows our hearts. He knows what we need to make it through a day. So in His kindness, He gave us a gift in the form of the Holy Spirit. As a Counselor, a Comforter, and a Friend, the Holy Spirit acts as our inner compass. He upholds us when times are hard and helps us hear God's directions. When the path of obedience grows dark, the Spirit floods it with light. What revelation! He lives within us. Therefore, our prayers are lifted to the Father, to the very throne of God. Whatever petitions we have, we may rest assured they are heard.

Father God, how blessed I am to come into Your presence.
Help me, Father, when I am weak. Guide me this day. Amen.

Day 96

THE MISSING PIECES

Trust the LORD with all your heart,
and don't depend on your own understanding.
PROVERBS 3:5 NCV

Life is confusing. No matter how hard we try, we can't always make sense of it. We don't like it when that happens, and so we keep trying to determine what's going on, as though we were trying puzzle pieces to fill in a picture we long to see. Sometimes, though, we have to accept that in this life we will never be able to see the entire image. We have to trust God's grace for the missing pieces.

Dear Lord, my own understanding is awfully limited,
and yet I still sometimes try to depend on it. Help me
to trust You with 100 percent of my heart. Amen.

Day 97
LISTENING CLOSELY

I will listen to what God the LORD says.
PSALM 85:8 NIV

In today's hurried world, with all of the surrounding noise, it's easy to ignore the still, small voice nudging us in the right direction. We fire off requests, expect microwave-instant answers, and get aggravated when nothing happens. Our human nature demands a response. How will we know what to do/think/say if we do not listen? As the worship song "Speak to My Heart" so beautifully puts it, when we are "yielded and still" then He can "speak to my heart."

Listening is a learned art, too often forgotten in the busyness of a day. The alarm clock buzzes, we hit the floor running, toss out a prayer, maybe sing a song of praise, grab our car keys, and are out the door. If only we'd slow down and let the heavenly Father's words sink into our spirits, what a difference we might see in our prayer life. This day, stop. Listen. See what God has in store for you.

Lord, how I want to surrender and seek Thy will.
Please still my spirit and speak to me. Amen.

Day 98

LOCATION, LOCATION, LOCATION

Those who live in the shelter of the Most High will find rest in the shadow of the Almighty. This I declare about the LORD: He alone is my refuge, my place of safety; he is my God, and I trust him.

PSALM 91:1–2 NLT

If something is getting you down in life, check your location. Where are your thoughts? Let what the world has conditioned you to think go in one ear and out the other. Stand on the truth, the promises of God's Word. Say of the Lord, "God is my refuge! I am hidden in Christ! Nothing can harm me. In Him I trust!" Say it loud. Say it often. Say it over and over until it becomes your reality. And you will find yourself dwelling in that secret place every moment of the day.

God, You are my refuge. When I abide in You, nothing can harm me. Your Word is the truth on which I rely. Fill me with Your light and the peace of Your love. It's You and me, Lord, all the way! Amen.

Day 99

THE GIFT OF ENCOURAGEMENT

We have different gifts. . . . If it is to
encourage, then give encouragement.
Romans 12:6, 8 niv

Paul spoke of encouraging as a God-given desire to proclaim God's Word in such a way that it touches hearts to move them to receive the Gospel. Encouragement is a vital part to witnessing because encouragement is doused with God's love. For the believer, it stimulates our faith to produce a deeper commitment to Christ. It brings hope to the disheartened or defeated soul. It restores hope. How will you know your spiritual gift? Ask God and then follow the desires He places on your heart.

Father, help me tune in to the needs of those around
me so that I might encourage them for the Gospel's
sake and for Your glory and for their good.

Day 100

WISE ENOUGH TO LEAD

"To God belong wisdom and power;
counsel and understanding are his."

JOB 12:13 NIV

The word *wisdom* comes from the same root words that have to do with vision, the ability to see into a deeper spiritual reality. Where else can we turn for the grace to see beneath life's surface except to God? Who else can we trust to be strong enough and wise enough to lead us to our eternal home?

Lord, my vision is far from twenty-twenty. Help me see
the world through Your lens of wisdom. Bestow on me Your
counsel, and fill me with Your understanding. Amen.

Day 101
PRAY ABOUT EVERYTHING

The LORD directs the steps of the godly.
He delights in every detail of their lives.
PSALM 37:23 NLT

The Bible says that the Lord delights in every detail of His children's lives. And no matter how old a believer is, that person is and always will be God's child.

Adult prayers don't have to be well ordered and formal. God loves hearing His children's voices, and no detail is too little or dull to pray about. Tell God that you hope the coffeehouse will have your favorite pumpkin-spice latte on their menu. Ask Him to give you patience as you wait in line. Thank Him for how wonderful that coffee tastes! Get into the habit of talking with Him all day long, because He loves you and delights in all facets of your life.

Dear God, teach me to pray about everything
with childlike innocence and faith. Amen.

Day 102
POWER OF THE WORD

*"The Spirit gives life; the flesh counts for nothing. The words
I have spoken to you—they are full of the Spirit and life."*
JOHN 6:63 NIV

Jesus told His followers that His words were Spirit and life. When we hear His Word, meditate on it, pray it, memorize it, and ask for faith to believe it, He comes to us in it and transforms our lives through it. Once the Word is in our minds or before our eyes and ears, the Holy Spirit can work it into our hearts and our consciences. Jesus told us to abide in His Word. . .putting ourselves in a place to hear and receive the Word. The rest is the beautiful and mysterious work of the Spirit.

*Thank You, Jesus, the Living Word, who changes my heart
and my mind through the power of Your Word. Amen.*

Day 103

GOD'S PROMISES BRING HOPE

*"For I know the plans I have for you," declares
the LORD, "plans to prosper you and not to harm
you, plans to give you hope and a future."*

JEREMIAH 29:11 NIV

The writer of the well-known hymn "It Is Well with My Soul" penned those words at the most grief-stricken time of his life after his wife and three children were tragically killed at sea. His undaunted faith remained because he believed in a God who was bigger than the tragedy he faced. God's promises gave him hope and encouragement. Despite your circumstances, God has a plan for you, one that will give you encouragement and hope and a brighter future.

*Father, may I always say, "It is well with my soul," knowing
Your promises are true and I can trust You no matter what.*

Day 104

EVER WIDER

A longing fulfilled is a tree of life.
PROVERBS 13:12 NIV

Take stock of your life. What were you most hoping to achieve a year ago? (Or five years ago?) How many of those goals have been achieved? Sometimes, once we've reached a goal, we move on too quickly to the next one, never allowing ourselves to find the grace God wants to reveal within that achievement. With each goal reached, His grace spreads out into your life, like a tree whose branches grow ever wider.

God, help me to find the balance between moving forward and looking back. Give me moments to pause and reflect on how far I have come with Your grace. Amen.

Day 105

EARNEST PRAYER

*"If. . .My people, who are called by My Name, humble
themselves, and pray and seek (crave, require as a necessity)
My face and turn from their wicked ways, then I will hear
[them] from heaven, and forgive their sin and heal their land."*

2 CHRONICLES 7:13–14 AMP

The Amplified Bible specifies how believers are to humble themselves and pray. We are to seek, crave, and require of necessity God's face.

We should *seek* God relentlessly.

Crave. Our desire for God's presence in our lives ought to be strong and irresistible.

Necessity. Our hearts need God for survival. He is our one and only true necessity.

When you pray, call out to God with your whole heart. Prayer must be more than an afterthought to close each day, as eyelids grow heavy and sleep wins the battle. Seek God. Crave and require His face. Turn toward Him. He stands ready to hear, to forgive, and to heal.

Lord, be my greatest desire, my craving, my all. Amen.

Day 106
CAN GOD INTERRUPT YOU?

In their hearts humans plan their course,
but the LORD establishes their steps.
PROVERBS 16:9 NIV

Have you ever considered that perhaps God has ordained our interruptions? Perhaps, just perhaps, God may be trying to get your attention. There is nothing wrong with planning our day. However, we have such limited vision. God sees the big picture. Be open. Be flexible. Allow God to change your plans in order to accomplish His divine purposes. Instead of becoming frustrated, look for ways the Lord might be working. Be willing to join Him. When we do, interruptions become blessings.

Dear Lord, forgive me when I am so rigidly locked into
my own agenda that I miss Yours. Give me Your eternal
perspective so that I may be open to divine interruptions. Amen.

Day 107

HIS STEADY HAND

The LORD makes firm the steps of the one who
delights in him; though he may stumble, he will
not fall, for the LORD upholds him with his hand.

PSALM 37:23–24 NIV

The Lord knows there are times when we will stumble. We may even backslide into the very activity that caused us to call on the Lord for salvation in the first place. But His Word assures us His love is eternal and when we cry out to Him, He will hear. Do not be discouraged with those stumbling blocks in your path, because the Lord is with you always. Scripture tells us we are in the palm of His hand. Hope is found in the Lord. He delights in us and wants the very best for us because of His perfect love.

Lord God, the cross was necessary for sinners like me.
I thank You that You loved me enough to choose me and
that I accepted the free gift of salvation. Amen.

Day 108
JUST WHAT WE NEED

God can pour on the blessings in astonishing ways so
that you're ready for anything and everything, more
than just ready to do what needs to be done.

2 CORINTHIANS 9:8 MSG

Blessings are God's grace visible to us in tangible form. Sometimes
they are so small we nearly overlook them—the sun on our faces,
the smile of a friend, or food on the table—but other times they
amaze us. Day by day, God's grace makes us ready for whatever
comes our way. He gives us exactly what we need.

God, the more I see Your blessings, the more they
seem to pour out on me. Give me Your grace to
receive and eyes to see Your goodness. Amen.

Day 109

PRAYING FOR ALL PEOPLE

I urge, then, first of all, that petitions, prayers, intercession and thanksgiving be made for all people—for kings and all those in authority, that we may live peaceful and quiet lives in all godliness and holiness. This is good, and pleases God our Savior, who wants all people to be saved and to come to a knowledge of the truth.

1 TIMOTHY 2:1–4 NIV

Whether we like the person who is in office or not, God commands us to pray for those He placed in authority over us. In ancient times, this could have meant praying for those who hated Christians and were possibly plotting harm to them. Even today, as issues concerning Christ followers emerge, we are called to pray for all people, including those with whom we don't see eye to eye politically. Today's scripture reminds us that to do so is good and pleasing to the Lord.

Gracious Lord, thank You for the admonition to pray for all people, including those whom we disagree with. All people are precious to You, Lord. Please help me put my own feelings aside and be obedient in praying for all those in authority. Amen.

Day 110

GOD'S MOUNTAIN SANCTUARY

And seeing the multitudes, he went up into a mountain:
and. . .his disciples came unto him: and he
opened his mouth, and taught them.
MATTHEW 5:1–2 KJV

Jesus often retreated to a mountain to pray. There He called His disciples to depart from the multitudes so that He could teach them valuable truths—the lessons we learn from nature. Do you yearn for a place where problems evaporate like the morning dew? Do you need a place of solace? God is wherever you are—behind a bedroom door, nestled alongside you in your favorite chair, or even standing at a sink full of dirty dishes. Come away and enter God's mountain sanctuary.

Heavenly Father, I long to hear Your voice and to
flow in the path You clear before me. Help me to
find sanctuary in Your abiding presence. Amen.

Day 111
I GIVE UP

*God so loved the world that he gave his one
and only Son, that whoever believes in him
shall not perish but have eternal life.*

JOHN 3:16 NIV

Our Creator cares enough about us to delve into our everyday lives and help us. Through the Holy Spirit within, God's gentle hand of direction will sustain each of us, enabling us to grow closer to our Father. The closer we grow, the more like Him we desire to be. Then His influence spreads through us to others. When we surrender, He is able to use our lives and enrich others. What a powerful message: give up and give more!

*Lord, thank You for loving us despite our frailties.
What an encouragement to me today. Amen.*

Day 112
LEADING

But since we belong to the day, let us be sober, putting on faith and love as a breastplate, and the hope of salvation as a helmet.
1 Thessalonians 5:8 niv

We sometimes think of discipline as a negative thing, as something that asks us to sacrifice and punish ourselves. But really the word has more to do with the grace we receive from instruction and learning, from following a master. Like an athlete who follows her coach's leading, we are called to follow our Master, wearing His uniform of love and His helmet of hope.

Heavenly Father, You are my Master, my Guide, my Coach, my everything. Thank You for Your grace and for giving me the tools I need to be self-controlled, faithful, loving, and hopeful. Amen.

Day 113

PUBLIC PRAYER

So I bow in prayer before the Father from whom
every family in heaven and on earth gets its true name.
EPHESIANS 3:14–15 NCV

A heartfelt prayer offered in public glorifies God and allows others to feel His presence; however, the scriptures include a warning about public prayer. Matthew 6:5 advises people not to act like the hypocrites who want to be seen and heard praying just to show how pious and religious they are. Public prayer must be sincere and directed toward God and not toward others.

Every day, Christians gather together, bow their heads, and pray publicly in churches, at prayer groups, at funeral and memorial services, in restaurants before meals, and even around school flagpoles. They pray sincerely, sometimes silently and sometimes aloud, setting aside the world and entering into God's presence.

Are you shy about praying in public? Don't be. Step out in faith, bow your head, and pray like God is the only One watching.

Heavenly Father, I am not ashamed to bow my
head and be in Your presence wherever I go. Amen.

Day 114

HOW ABOUT SOME FUN?

A twinkle in the eye means joy in the heart,
and good news makes you feel fit as a fiddle.
PROVERBS 15:30 MSG

God does not want His kids to be worn out and stressed out. A little relaxation, recreation, and—yes—*fun* are essential components of a balanced life. Even Jesus and His disciples found it necessary to get away from the crowds and pressures of ministry to rest. There's a lot of fun to be had out there—playing tennis or golf, jogging, swimming, painting, knitting, playing a musical instrument, visiting an art gallery, playing a board game, or going to a movie, a play, or a football game. Have you had any fun this week?

Lord, You are the One who gives balance to my life.
Help me to find time today for a little relaxation,
recreation, and even fun. Amen.

Day 115

FULL REDEMPTION AND LOVE

Israel, put your hope in the LORD, for with the LORD
is unfailing love and with him is full redemption.

PSALM 130:7 NIV

The Bible tells us that God removes our sins as far as the east is from the west (Psalm 103:2) and that He remembers our sin no more (Isaiah 43:25, Hebrews 8:12). It's so important to confess your sins to the Lord as soon as you feel convicted and then turn from them and move in a right direction. There is no reason to hang your head in shame over sins of the past. Don't allow the devil to speak lies into your life. You have full redemption through Jesus Christ!

Dear Jesus, I confess my sin to You. Thank You for blotting out
each mistake and not holding anything against me. Help me to
make right choices through the power of Your Spirit inside me.

Day 116
REACH OUT TO HIM

"Your words have supported those who were falling; you encouraged those with shaky knees."

JOB 4:4 NLT

God knows how weak and shaky we feel some days. He understands our feelings. After all, He made us, so He understands how prone humans are to discouragement. He doesn't blame us for being human, but He never leaves us helpless either. His grace is always there, like a hand held out to us, simply waiting for us to reach out and grasp it.

Lord, thank You for Your words that give me support and hope when I am falling; thank You for encouraging me when I feel shaky. May I rest in Your grace and truth. Amen.

Day 117
THE POWER OF PRAYER

*Confess your sins to each other and pray for each other so that
you may be healed. The earnest prayer of a righteous per-
son has great power and produces wonderful results.*

JAMES 5:16 NLT

Have you given your heart to Jesus? If you have accepted Him as
your Savior, you have taken on the *righteousness* of Christ. Certainly
you are not perfect. In your humanity, you still sin and fall short.
But God sees you through a Jesus lens! And so your prayers reach
the ears of your heavenly Father.

Pray often. Pray earnestly. Pray without ceasing. Pray about
everything. Prayer changes things. Look at Jesus' example of prayer
during His time on earth. He went away to quiet places such as
gardens to pray. He prayed in solitude. He prayed with all His heart.
If anyone was busy, it was the Messiah! But Jesus always made time
to pray. We ought to follow His example. Prayer changes things.

*Lord, help me to believe in the power of
prayer and to make time for it daily. Amen.*

Day 118

LADIES IN WAITING

I will wait for the LORD. . . . I will put my trust in him.
ISAIAH 8:17 NIV

Do we want joy without accepting heartache? Peace without living through the stress? Patience without facing demands? God sees things differently. He's giving us the opportunity to learn through these delays, irritations, and struggles. Like Isaiah, we need to learn the art of waiting on God. He will come through every time—but in *His* time, not ours. The wait may be hours or days, or it could be years. But God is always faithful to provide for us. It is when we learn to wait on Him that we will find joy, peace, and patience through the struggle.

Father, You know what I need, so I will wait. Help me be patient, knowing that You control my situation and that all good things come in Your time. Amen.

Day 119

PASS IT ON!

*After the usual readings from the books of Moses and
the prophets, those in charge of the service sent them
this message: "Brothers, if you have any word of
encouragement for the people, come and give it."*
ACTS 13:15 NLT

Encouragement brings hope. Have you ever received a word
from someone that instantly lifted your spirit? Did you receive
a bit of good news or something that diminished your negative
outlook? Perhaps a particular conversation helped to bring your
problems into perspective. Paul passed on encouragement, and
many benefited. So the next time you're encouraged, pass it on!
You may never know how your words or actions benefited some-
one else.

*Lord, thank You for the wellspring of
encouragement through Your Holy Word.*

Day 120
HEARTFELT

For we live by believing and not by seeing.
2 CORINTHIANS 5:7 NLT

The world of science tells us that only what can be seen and measured is truly real. But our hearts know differently. Every day, we depend on the things we believe—our faith in God and in our friends and family, our commitment to give ourselves to God and others—and it is these invisible beliefs that give us grace to live.

Father, my mind is so prone to cling to what is tangible. However, my heart is sure that You are as real as the bright shining sun. Fill me with confidence and trust. Amen.

Day 121

STOP, BREATHE, PRAY…REPEAT

*Do not be anxious about anything, but in every situation,
by prayer and petition, with thanksgiving, present your requests
to God. And the peace of God, which transcends all understanding,
will guard your hearts and your minds in Christ Jesus.*

PHILIPPIANS 4:6–7 NIV

Being a woman in these times is challenging. Many of us are working demanding jobs, managing our homes and crazy schedules, and taking care of children or aging parents. Often, we feel we don't have enough time to get everything done, let alone take care of ourselves properly. All of this creates stress and anxiety, which just makes many of these situations worse.

What can you do when it seems the world is falling down around your shoulders? Stop. Take a deep breath, and then settle your mind on Jesus. Give Him the situation, the harried thoughts, the worries. He will provide whatever we need, even the peace that will get us through the most difficult circumstances.

*Father God, we are thankful that we can take any worried
thought or situation to You in prayer. You tell us that You
will provide for us and will even give us Your peace!*

Day 122

DREAM MAKER

"What no eye has seen, what no ear has heard, and
what no human mind has conceived"—the things
God has prepared for those who love him.

1 CORINTHIANS 2:9 NIV

Dreams, goals, and expectations are part of our daily lives. We have an idea of what we want and how we're going to achieve it. Disappointment can raise its ugly head when what we wanted— what we expected—doesn't happen like we thought it should or doesn't happen as fast as we planned. God knows the dreams He has placed inside of you. He created you and knows what you can do—even better than you know yourself. Maintain your focus—not on the dream but on the Dream Maker—and together you will achieve your dream.

God, thank You for putting dreams in my heart. I refuse to quit.
I'm looking to You to show me how to reach my dreams. Amen.

Day 123

HE WON'T LET YOU DOWN

*I tell you that Christ has become a servant of the
Jews on behalf of God's truth, so that the promises
made to the patriarchs might be confirmed.*

ROMANS 15:8 NIV

Everyone has been hurt at one time or another by a broken promise. When that happens, it is best to forgive and go on. People are just people. They mess up. But there is One who will never break His promises to us—our heavenly Father. We can safely place our hope in Him. Choose to place your hope in God's promises. You won't be discouraged by time—God's timing is always perfect. You won't be discouraged by circumstances—God can change everything in a heartbeat. He is faithful.

*Lord, I choose this day to place my trust in You,
for I know You're the one true constant. Amen.*

Day 124

SENSITIVITY

At the same time, don't be callous in your exercise of freedom, thoughtlessly stepping on the toes of those who aren't as free as you are. I try my best to be considerate of everyone's feelings in all these matters; I hope you will be, too.

1 CORINTHIANS 10:32–33 MSG

The person who walks in grace doesn't trip over other people's feet. She doesn't shove her way through life like a bull in a china shop. Instead, she allows the grace she has so freely received to make her more aware of others' feelings. With God-given empathy, she is sensitive to those around her, sharing the grace she has received with all she meets.

Jesus, I am grateful for the freedom I have in You. Help me to see past my differences with others so that I can show them empathy from a gracious and compassionate heart. Amen.

Day 125

FOCUSED PRAYER

*Pray in the Spirit at all times and on every occasion. Stay alert
and be persistent in your prayers for all believers everywhere.*
Ephesians 6:18 nlt

The Bible warns us to stay alert and to pray persistently. The key is
to focus on Jesus even in the midst of the storm. If the captain of
a ship or the pilot of a plane loses focus in the middle of a storm,
it can be very dangerous for all involved. Our job as believers is
to trust the Lord with the outcome and to remain deliberate and
focused in our prayers.

The Bible does not say to pray when it is convenient or as a
last resort. It does not say to pray just in case prayer might work
or to add prayer to a list of other things we are trying. We are
instructed in Ephesians to pray at *all* times and on *every* occasion.
When you pray, pray in the Spirit. Pray for God's will to be done.
Pray in the name of Jesus.

*Jesus, I set my eyes upon You, the Messiah,
my Savior, Redeemer, and Friend. Amen.*

Day 126

CHOOSING WISELY

Our mouths were filled with laughter.
PSALM 126:2 NIV

We women often plan perfect family events, only to find out how imperfectly things can turn out. The soufflé falls; the cat leaps onto the counter and licks the cheese ball; little Johnny drops Aunt Martha's crystal gravy dish (full of gravy, of course). The Bible says that Sarah laughed at the most unexpected, traumatic time of her life—when God announced that she would have a baby at the age of ninety (Genesis 18:12). At this unforeseen turn of events, she could either laugh, cry, or run away screaming. She chose to laugh.

Lord, give us an extra dollop of grace and peace to laugh about unexpected dilemmas that pop up. And to remember that our reaction is a choice. Amen.

Day 127

STRENGTH IN THE LORD

The LORD is my light and my salvation—
whom shall I fear? The LORD is the stronghold
of my life—of whom shall I be afraid?

PSALM 27:1 NIV

At times, this world can be a tough, unfair, lonely place. Since the fall of man in the garden, things have not been as God originally intended. The Bible assures us that we will face trials in this life, but it also exclaims that we are more than conquerors through Christ who is in us! When you find yourself up against a tribulation that seems insurmountable, *look up*. Christ is there. He goes before you, stands with you, and is backing you up in your time of need. You may lose everyone and everything else in this life, but nothing has the power to separate you from the love of Christ. Nothing.

Jesus, I cling to the hope I have in You. You are my Rock,
my Stronghold, my Defense. I will not fear,
for You are with me always. Amen.

Day 128

WHAT YOU CRAVE

*Take delight in the LORD, and he
will give you your heart's desires.*
PSALM 37:4 NLT

Do you ever feel as though God wants to deny you what you
want, as though He's a cruel stepparent who takes pleasure in
thwarting you? That image of God is a lie. He's the One who
placed your heart's desires deep inside you. As you turn to Him,
knowing that He alone is the Source of all true delight, He will
grant you what your heart most truly craves.

*Father, I cannot imagine that You love me so much that
You would reach out and give me the things my heart
desires. Yet Your Word is truth. Thank You. Amen.*

Day 129

THE RIGHT FOCUS

Turning your ear to wisdom and applying your heart to understanding—indeed, if you call out for insight and cry aloud for understanding, and if you look for it as for silver and search for it as for hidden treasure, then you will understand the fear of the LORD and find the knowledge of God.

PROVERBS 2:2–5 NIV

Even when you're looking in the right direction, you can still miss something because your focus is slightly off. This can be the challenge in our relationship with God. We can ask God a question and be really intent on getting the answer, only to find that His response to us was there all along—just not the answer we expected or wanted.

Frustration and stress can keep us from clearly seeing the things that God puts before us. Time spent in prayer and meditation on God's Word can often wash away the dirt and grime of the day-to-day and provide a clear picture of God's intentions for our lives. Step outside the pressure and into His presence, and get the right focus for whatever you're facing today.

Lord, help me to avoid distractions and keep my eyes on You. Amen.

Day 130

DIFFICULT PEOPLE

*Do not turn your freedom into an opportunity for
the flesh, but serve one another through love.*

GALATIANS 5:13 NASB

Sometimes, like David, we need to turn our skirmishes with others
over to the Lord. Then, by using our weapons—God's Word and a
steadfast faith—we need to love and forgive others as God loves
and forgives us. Although we may not like to admit it, we have
all said and done some pretty awful things ourselves, making the
lives of others difficult. Yet God has forgiven us *and* continues
to love us. So do the right thing. Pull your feet out of the mire
of unforgiveness, sidestep verbal retaliation, and stand tall in the
freedom of love and forgiveness.

*The words and deeds of others have left me wounded and
bleeding. Forgiveness and love seem to be the last things
on my mind. Change my heart, Lord. Help me to love
and forgive others as You love and forgive me. Amen.*

Day 131

THANKFUL HEART

I will praise you, LORD, with all my heart.
I will tell all the miracles you have done.

PSALM 9:1 NCV

When you choose to approach life from the positive side, you can find thankfulness in most of life's circumstances. It completely changes your outlook, your attitude, and your countenance. God wants to bless you. When you are tempted to feel sorry for yourself or to blame others or God for difficulties, push PAUSE. Take a moment and rewind your life. Look back and count the blessings that God has given you. As you remind yourself of all He has done for you and in you, it will bring change to your attitude and give you hope in the situation you're facing. Count your blessings today.

Lord, I am thankful for my life and all You have done
for me. When life happens, help me to respond to it in
a healthy, positive way. Remind me to look to You and
trust You to carry me through life's challenges.

Day 132

FOR ETERNITY

My health may fail, and my spirit may grow weak,
but God remains the strength of my heart; he is mine forever.
PSALM 73:26 NLT

Sooner or later, our bodies let us down. Even the healthiest of us will one day have to face old age. When our bodies' strength fails us, we may feel discouraged and depressed. But even then we can find joy and strength in our God. When our hearts belong to the Creator of the universe, we realize we are far more than our bodies. Because of God's unfailing grace, we will be truly healthy for all eternity.

God, when I feel discouraged by aches and pains that bring
me down, help me to remember that my life here on earth
is barely a breath in the scope of eternity. Amen.

Day 133

PRAYER AND THE WORD
UNLOCK THE DOOR

*I pray that your hearts will be flooded with light so that you can
understand the confident hope he has given to those he called—
his holy people who are his rich and glorious inheritance.*

EPHESIANS 1:18 NLT

Math is a language all its own. Unfortunately, many students
struggle to learn that language. Sometimes they never understand
it completely but retain just enough of the language to make it
through required courses.

Your spiritual life is also a different language. God's ways are
not the ways of this world. Often His ways of doing things are
similar to learning a new language. Prayer can unlock the door
to understanding God's Word and His design for your life. As
you spend time with God in prayer asking for understanding of
His Word, His truth will speak to you in a brand-new way. The
Holy Spirit will help you unlock the secrets of His purpose and
plan for your life.

*Heavenly Father, thank You for the Bible. Help me to read it with
understanding and come to know You in a whole new way. Amen.*

Day 134

KING FOREVER

You, O God, are my king from ages past,
bringing salvation to the earth.
PSALM 74:12 NLT

Sometimes it seems like every part of our lives is affected by change. Nothing ever seems to stay the same. These changes can leave us feeling unsteady in the present and uncertain about the future. It's different in God's kingdom. He's the King now, just as He was in the days of Abraham. His reign will continue until the day His Son returns to earth and then on into eternity. We can rely—absolutely depend on—His unchanging nature. Take comfort in the stability of the King—He's our Leader now and forever!

Almighty King, You are my Rock. When my world is in
turmoil and changes swirl around me, You are my Anchor
and my center of balance. Thank You for never changing. Amen.

Day 135
WHAT IF?

The LORD will keep you from all harm—
he will watch over your life.
PSALM 121:7 NIV

Feeling safe and secure rests not in the world or in other human beings but with God alone. He is a Christian's help and hope in every frightening situation. He promises to provide peace to everyone who puts their faith and trust in Him. What are you afraid of today? Allow God to encourage you. Trust Him to bring you through it and to give you peace.

Dear Lord, hear my prayers, soothe me
with Your words, and give me peace. Amen.

Day 136

OPEN HOMES

Be quick to give a meal to the hungry,
a bed to the homeless—cheerfully.

1 PETER 4:9 MSG

Because our homes are our private places, the places we retreat to when we're tired to find new strength, it's hard sometimes to open our homes to others. It's bad enough that we have to cope with others' needs all day long, we feel, without having to bring them home with us! But God calls us to offer our hospitality, and He will give us the grace to do it joyfully.

God, You have blessed me with a home—
a sanctuary. And I am so grateful for it. Help me
to joyfully share that blessing with others. Amen.

Day 137

PRAY FOR CHRISTIAN HOUSEHOLDS

When she speaks, her words are wise,
and she gives instructions with kindness.
PROVERBS 31:26 NLT

In Christian households, children learn about God's love and faithfulness. Discipline is administered out of loving-kindness, not anger, and love is taught through the parents' example. It is a home in which Christlike wisdom is passed from generation to generation.

In Timothy's household (see 2 Timothy 1:5), he learned from his mother's and grandmother's faith; and according to Paul, those seeds of faith grew in young Timothy and led him to become a servant of the Lord.

Whether you are married or single, have children or not, you can plant seeds of faith through your own Christian example and prayer. Pray for all children that they will grow up in godly homes, and pray for women everywhere that they will raise their children in Christian households and remain always faithful to God.

Heavenly Father, shine Your light through me
today so that I might be an example to others. Amen.

Day 138

CARTWHEELS OF JOY

*I'm singing joyful praise to G*OD*. I'm turning cartwheels
of joy to my Savior God. Counting on G*OD*'s Rule
to prevail, I take heart and gain strength. I run like
a deer. I feel like I'm king of the mountain!*
H ABAKKUK 3:18–19 MSG

What would happen if we followed the advice of the psalmist and
turned a cartwheel of joy in our hearts—regardless of the circum-
stances—then leaned into Him and trusted His rule to prevail?
Think of the happiness and peace that could be ours with a total
surrender to God's care. Taking a giant step, armed with scriptures
and praise and joy, we can surmount any obstacle put before us,
running like a deer, climbing the tall mountains. With God at our
side, it's possible to be king of the mountain.

*Dear Lord, I need Your help. Gently guide me so I might learn
to lean on You and become confident in Your care. Amen.*

Day 139

MY REFUGE

God is our refuge and strength,
always ready to help in times of trouble.
PSALM 46:1 NLT

What is your quiet place? The place you go to get away from
the fray, to chill out, think, regroup, and gain perspective? Is it a
hammock nestled beneath a canopy of oaks in your backyard. . .
nobody around but birds, squirrels, an occasional wasp, God,
and you? Somewhere you can pour out your heart to the Lord, hear
His comforting voice, and feel His strength refresh your heart?
We all need a quiet place. God, our Refuge, will meet us there.

Father, thank You for my special place. . .the place
I love to go and spend time in Your presence. Amen.

Day 140

BEYOND INTELLIGENCE

*The fastest runner does not always win the race, the strongest
soldier does not always win the battle, the wisest does not
always have food. . . . Time and chance happen to everyone.*

ECCLESIASTES 9:11 NCV

How smart do you think you are? Do you assume you will be able
to think your way through life's problems? Many of us do—but
God reminds us that some things are beyond the scope of our
intelligence. Some days life simply doesn't make sense. But even
then, grace is there with us in the chaos. When we can find no
rational answers to life's dilemmas, we have no choice but to rely
absolutely on God.

*God, I am conditioned to rely on strength, speed, and efficiency.
While those things are useful, I know that wisdom is more
important. Help me to seek answers directly from You. Amen.*

Day 141

HOW LONG HAS IT BEEN?

*Trust in him at all times, you people; pour out
your hearts to him, for God is our refuge.*
PSALM 62:8 NIV

Has it been a long time since you've completely poured out your heart to God? Not just your everyday prayers for family and friends, but a complete and exhaustive outpouring of your heart to the Lord? Oftentimes we run to friends or spiritual counselors in times of heartache and trouble, but God wants us to pour out our hearts to Him first. He is our Refuge, and we can trust Him to heal our hearts completely.

The next time you reach for the phone to call up a friend and share all of your feelings, stop and pray first. Share your heart with God and gain His perspective on your troubles. The God who created you knows you better than anyone. Let Him be your first point of contact in any situation.

*Heavenly Father, help me to trust that You are
here for me—to listen and to guide me. Give me
wisdom to make decisions that honor You. Amen.*

Day 142
STEP BY STEP

*For we walk by faith, not by sight [living
our lives in a manner consistent with our
confident belief in God's promises].*
2 CORINTHIANS 5:7 AMP

The experiences and circumstances of our lives can often lead us
to lose heart. The apostle Paul exhorts us to look away from this
present world and rely on God by faith. Webster's dictionary defines *faith* as a firm belief and complete trust. Trusting, even
when our faith is small, is not an easy task. Today, grasp hold of
God's Word and feel His presence. Hold tightly and don't let
your steps falter. He is beside you and will lead you.

*Dear heavenly Father, today I choose to clutch
Your hand and feel Your presence as I trudge the
pathways of my life. I trust You are by my side. Amen.*

Day 143
INCREASING VISIBILITY

"Where then is my hope. . . ?"
JOB 17:15 NIV

On hectic days when fatigue takes its toll, when we feel like corn-less husks, hope disappears. When hurting people hurt people and we're in the line of fire, hope vanishes. When ideas fizzle and efforts fail, when we throw the spaghetti against the wall and nothing sticks, hope seems lost. But we must remember it's only temporary. The mountaintop isn't gone just because it's obscured by fog. Visibility will improve tomorrow, and hope will rise.

God of hope, I am thankful to know You. . .and to
trust that because of You, hope will rise. Amen.

Day 144

FULL!

"I came that they may have and enjoy life, and have it in abundance [to the full, till it overflows]."

JOHN 10:10 AMP

The life we have in Christ is not restricted or narrow. Grace doesn't flow to us in a meager trickle; it fills our life to the fullest. God's grace comes to us each moment, day after day, year after year, a generous flood that fills every crack and crevice of our lives—and then overflows.

Jesus, I sometimes long so deeply for heaven that I forget You have big plans for me on this earth. Thank You that those plans involve a rich and abundant life. Amen.

Day 145

A REFUGE FROM DESPAIR

Hear my cry, God; give Your attention to my prayer. From the
end of the earth I call to You when my heart is faint; lead me
to the rock that is higher than I. For You have been a refuge for
me, a tower of strength against the enemy. Let me dwell in Your
tent forever; let me take refuge in the shelter of Your wings.

PSALM 61:1–4 NASB

King David clung with tenacity to the fact that no matter how desperate his situation appeared, God was as immovable as a huge rock or boulder. Although David's trials may differ from yours, you too can use strong coping mechanisms.

First, David acknowledged that God remained all powerful, despite life's circumstances. And second, David looked back at God's past rescues. "My soul is in despair within me; therefore I remember You from the land of the Jordan and the peaks of Hermon, from Mount Mizar. Deep calls to deep at the sound of Your waterfalls; all Your breakers and Your waves have passed over me. The LORD will send His goodness in the daytime; and His song will be with me in the night, a prayer to the God of my life" (Psalm 42:6–8 NASB).

Lord, I search for a way through the torrents of despair.
How precious is the knowledge that You hear and care. Amen.

Day 146

BIBLICAL ENCOURAGEMENT FOR YOUR HEART

Don't be concerned about the outward beauty of fancy hairstyles,
expensive jewelry, or beautiful clothes. You should clothe yourselves
instead with the beauty that comes from within, the unfading
beauty of a gentle and quiet spirit, which is so precious to God.

1 PETER 3:3–4 NLT

God is concerned with what is on the inside. He listens to how you respond to others and watches the facial expressions you choose to exhibit. He sees your heart. The Lord desires that you clothe yourself with a gentle and quiet spirit. He declares this as unfading beauty, the inner beauty of the heart. Focus on this and no one will even notice whether your jewelry shines. Your face will be radiant with the joy of the Lord, and your heart will overflow with grace and peace.

Lord, grant me a quiet and gentle
spirit. I ask this in Jesus' name. Amen.

Day 147

LORD OF THE DANCE

Remember your promise to me; it is my only hope.
PSALM 119:49 NLT

The Bible contains many promises from God: He will protect us (Proverbs 1:33), comfort us (2 Corinthians 1:5), help in our times of trouble (Psalm 46:1), and encourage us (Isaiah 40:29). The word *encourage* comes from the root phrase "to inspire courage." Like an earthly father encouraging his daughter from backstage as her steps falter during her dance recital, our Papa God wants to inspire courage in us, if we only look to Him.

Promise Keeper, You are the one true source of courage. Thank You for Your promises and for giving me courage when I need it most.

Day 148

TEN PERCENT

The earth is the LORD's, and everything in it.
PSALM 24:1 NLT

Do you tithe? Giving 10 percent of your income specifically to God's work is a good discipline. But sometimes we act as though that 10 percent is God's and the other 90 percent is ours. We forget that everything is God's. Through grace, He shares all of creation with us. When we look at it that way, our 10 percent tithe seems a little stingy!

Heavenly Father, everything belongs to You—even the cattle on a thousand hills. Thank You for sharing Your wealth with me, and help me to share it lavishly with others. Amen.

Day 149

HOLY SPIRIT PRAYERS

*We do not know what to pray for as we should, but the Spirit
Himself intercedes for us with groanings too deep for words; and
He who searches the hearts knows what the mind of the Spirit is,
because He intercedes for the saints according to the will of God.*

ROMANS 8:26–27 NASB

Many times the burdens and troubles of our lives are too compli-
cated to understand. It's difficult for us to put them into words,
let alone know how to pray for what we need.

We can always take comfort in knowing that the Holy Spirit
knows, understands, and pleads our case before the throne of
God the Father. Our groans become words in the Holy Spirit's
mouth, turning our mute prayers into praise and intercession
"according to the will of God."

We can be encouraged, knowing that our deepest longings
and desires, maybe unknown even to us, are presented before
the God who knows us and loves us completely. Our names are
engraved on His heart and hands. He never forgets us; He inter-
venes in all things for our good and His glory.

*Father, I thank You for the encouragement these verses bring. May I
always be aware of the Holy Spirit's interceding on my behalf. Amen.*

Day 150
LIFTED UP

But those who trust in the LORD will find new strength.
They will soar high on wings like eagles. They will run
and not grow weary. They will walk and not faint.

ISAIAH 40:31 NLT

Do you ever have days when you ask yourself, "How much further can I go? How much longer can I keep going like this?" On days like that, you long to give up. You wish you could just run away from the world and hide. Trust God's grace to give you the strength you need, even then. Let Him lift you up on eagle's wings.

Heavenly Father, I place my trust in You. Thank You for the
promise that I will soar high on eagle's wings. Give me rest
for my weariness and strength for the journey. Amen.

Day 151
SMILING IN THE DARKNESS

"The hopes of the godless evaporate."
JOB 8:13 NLT

Hope isn't just an emotion; it's a perspective, a discipline, a way of life. It's a journey of choice. We must learn to override those messages of discouragement, despair, and fear that assault us in times of trouble and press toward the light. Hope is smiling in the darkness. It's confidence that faith in God's sovereignty amounts to something. . .something life changing, lifesaving, and eternal.

Father God, help me smile through the
darkness today. Thank You for hope. Amen.

Day 152
QUIET TIME

Be still before the LORD, and wait patiently for him.
PSALM 37:7 NRSV

Our lives are busy. Responsibilities crowd our days, and at night as we go to bed, our minds often continue to be preoccupied with the day's work, ticking off a mental to-do list even as we fall asleep. We need to set aside time to quiet our hearts. In those moments, we can let go of all our to-dos and wait for God's grace to take action in our lives.

God, thank You for this verse that reminds me of the gift of stillness. In my all-too-few quiet moments, help me to learn to wait patiently for You. Amen.

Day 153

TALKING TO GOD

One of his disciples said to him, "Lord, teach us to pray, just as John taught his disciples." He said to them, "When you pray, say: 'Father, hallowed be your name, your kingdom come. Give us each day our daily bread.'"

LUKE 11:1–3 NIV

Yes, God hears—and, although He knows what we need before we even ask Him, He *wants* us to pray. He even gave us instruction on how to pray. Our prayers don't have to be long or eloquent or even particularly organized. When Jesus taught His disciples to pray, the sample wasn't wordy. He simply taught the disciples to give God glory and to come to Him and ask for their daily needs.

But Luke 11 teaches us something beyond just an outline for prayer. The story shows clearly that if we ask God to teach us how to pray, He will. It's all part of the prayer—ask God to lead you, and then speak to Him from the heart.

Let's make it a habit to pray every day. Like the saying goes, practice makes perfect.

Dear God, teach me how to pray. Remind me that my words don't have to be profound. You're just looking for earnest thoughts from the heart. Amen.

Day 154

HE CARRIES US

*In his love and mercy he redeemed them. He lifted
them up and carried them through all the years.*

Isaiah 63:9 NLT

Are you feeling broken today? Depressed? Defeated? Run to Jesus
and not away from Him.

He will carry us—no matter what pain we have to endure. No
matter what happens to us. God sent Jesus to be our Redeemer.
He knew the world would hate, malign, and kill Jesus. Yet He
allowed His very flesh to writhe in agony on the cross—so that
we could also become His sons and daughters. He loved me, and
you, that much.

*Lord Jesus, thank You for coming to us—for not abandoning us
when we are broken. Thank You for Your work on the cross, for Your
grace, mercy, and love. Help me to seek You even when I can't feel
You, to love You even when I don't know all the answers. Amen.*

Day 155

SMALL BUT MIGHTY

"He has. . .exalted the humble."
LUKE 1:52 NLT

God delights in making small things great. He's in the business of taking scrap-heap people and turning them into treasures: Noah (the laughingstock of his city), Moses (stuttering shepherd turned national leader), David (smallest among the big and powerful), Sarah (old and childless), Mary (poor teenager), Rahab (harlot turned faith-filled ancestor of Jesus). So you and I can rejoice with hope! Let us glory in our smallness!

*I feel so very small today, God. Please remind
me that because I am Yours, I am worthy.
And that's all that matters!*

Day 156

THE CENTER OF OUR LIVES

*The apostles often met together and prayed
with a single purpose in mind.*

ACTS 1:14 CEV

What do you do when you get together with the people you're close to? You probably talk and laugh, share a meal, maybe go shopping or work on a project. But do you ever pray together? If prayer is the center of our lives, we will want to share this gift of grace with those we're closest to.

*Heavenly Father, when I meet together regularly with my sisters
and brothers, nudge us to pray with a single purpose, keeping
You in the center and uniting us with Your love. Amen.*

Day 157

VOCALIZING A PRAYER

"And when you are praying, do not use thoughtless
repetition as the Gentiles do, for they think that they
will be heard because of their many words."

MATTHEW 6:7 NASB

If you can remember the acrostic ACTS, you'll have an excellent formula for prayer: Adoration, Confession, Thanksgiving, and Supplication.

As we come before the Lord, we first need to honor Him as Creator, Master, Savior, and Lord. Reflect on who He is and praise Him. And because we're human, we need to confess and repent of our daily sins. Following this we should be in a mode of thanksgiving. Finally, our prayer requests should be upheld. Our usual order for requests is self, family members, and life's pressing issues. Keeping a prayer journal allows for a written record of God's answers.

Your prayers certainly don't have to be elaborate or polished. God does not judge your way with words. He knows your heart. He wants to hear from you.

Lord, Your Word says that my prayers rise up to heaven
like incense from the earth. Remind me daily
to send a sweet savor Your way! Amen.

Day 158

WOMAN OF WORTH

A wife of noble character who can find? She is worth far more than rubies. Her husband has full confidence in her and lacks nothing of value. She brings him good, not harm, all the days of her life.
PROVERBS 31:10–12 NIV

Are you the woman of worth that Jesus intends you to be? We often don't think we are. Between running a household, rushing to work, taking care of the children, volunteering for worthwhile activities, and still being a role model for our families, we think we've failed miserably. Sometimes we don't fully realize that learning to be a noble woman of character takes time. Our experiences can be offered to another generation seeking wisdom from others who have "been there." You are a woman of worth. God said so!

Father God, thank You for equipping me to be a woman of noble character. You tell me that I am more precious than jewels, and I claim and believe that wholeheartedly. I love You, Lord, and I will continue to put You first in my life. Help me to be the woman You intend me to be! Amen.

Day 159

JETS AND SUBMARINES

*No power in the sky above or in the earth be-
low. . .will ever be able to separate us from the love of
God that is revealed in Christ Jesus our Lord.*

<small>Romans 8:39 NLT</small>

Have you ever been diving amid the spectacular array of vivid color
and teeming life in the silent world under the sea? Painted fish
of rainbow hues are backlit by diffused sunbeams. Multi-textured
coral dot the gleaming white sand. You honestly feel as if you're
in another world. But every world is God's world. He soars above
the clouds with us and spans the depths of the seas. Nothing can
separate us from His love.

*Your love amazes me, Father. Just when I find myself
questioning how You could possibly love me so much,
I am reminded of the precious promises of Your Word.*

Day 160
SEE JESUS

God left nothing that is not subject to them. Yet at present we do not see everything subject to them. But we do see Jesus.
HEBREWS 2:8–9 NIV

We know that Jesus has won the victory over sin, and yet when we look at the world as it is right now, we still see sin all around us. We see pain and suffering, greed and selfishness, brokenness and despair. We know that the world is not ruled by God. Yet despite that, we can look past the darkness of sin. By grace, right now, we can see Jesus.

Jesus, when I am overwhelmed by the evil that seems to be winning in this world, remind me that You have won the victory. Give me the grace to see You. Amen.

Day 161

SO, TALK!

"No one can come to Me unless the Father who sent Me draws him [giving him the desire to come to Me]; and I will raise him up [from the dead] on the last day."

John 6:44 AMP

Fortunately for us human beings, God isn't easily offended. He is deeply committed to holding up His end of our relationship, and He doesn't want us to hide anything from Him. He already knows every thought we have, anyway. Why not talk to Him about those thoughts? Every concern we have, every little thing that's good, bad, or ugly.

Our Father always wants to talk. In fact, the very impulse to pray originates in God. In his book *The Pursuit of God*, author A. W. Tozer wrote, "We pursue God because, and only because, He has first put an urge within us that spurs us to the pursuit."

So, talk!

Lord God, it boggles my mind that You want to hear from me! And often! Your Word says that I can call out Your name with confidence. That You will answer me! Today, Lord, I give You praise, honor and glory—and my heart's deepest longings. Amen.

Day 162
LOVING SISTERS

But Ruth replied, "Don't urge me to leave you or to turn back from you. Where you go I will go, and where you stay I will stay. Your people will be my people and your God my God."
RUTH 1:16 NIV

The story of Ruth and Naomi is inspiring on many levels. Both women realized that their commitment, friendship, and love for each other surpassed any of their differences. They were a blessing to each other. Do you have girlfriends who would do almost anything for you? A true friendship is a gift from God. Those relationships provide us with love, companionship, encouragement, loyalty, honesty, understanding, and more! Lasting friendships are essential to living a balanced life.

Father God, thank You for giving us the gift of friendship. May I be the blessing to my girlfriends that they are to me. Please help me to always encourage and love them and to be a loving support for them in both their trials and their happiness. I praise You for my loving sisters! Amen.

Day 163
GO FOR IT

*When everything was hopeless, Abraham believed any-
way, deciding to live. . .on what God said he would do.*
Romans 4:18 msg

"You can't do that. It's impossible." Have you ever been told this?
Or just thought it because of fear or a previous experience with
failure? This world is full of those who discourage rather than
encourage. If we believe them, we'll never do anything. But if we,
like Abraham, believe that God has called us for a particular pur-
pose, we'll go for it despite our track records. Past failure doesn't
dictate future failure. If God wills it, He fulfills it.

*Help me to have the faith of Abraham,
Father God. . .to believe anyway!*

Day 164

RELAX...

But I am calm and quiet, like a baby with its mother.
I am at peace, like a baby with its mother.

PSALM 131:2 NCV

You know how a baby lies completely limp in her mother's arms, totally trusting and at peace? That is the attitude you need to practice. Let yourself relax in God's arms, wrapped in His grace. Life will go on around you, with all its noise and turmoil. Meanwhile, you are completely safe, totally secure, without a worry in the world. Lie back and enjoy the quiet!

Heavenly Father, thank You for the peace You
provide. Thank You that I can rest so gently
and comfortably in Your loving arms. Amen.

Day 165

WHEN GOD REDECORATES

God is the builder of everything.

HEBREWS 3:4 NIV

God—the Renovator of hearts—doesn't work cautiously. When He begins renovations, He removes (or allows the removal of) all existing supports. Maybe that "support" is health—ours or a loved one's. Maybe it's our savings. Maybe it's something else. Our lives, as we know them, crash. We hurt. We don't know how we can go on.

But God knows. If we let Him, He'll replace the temporary supports we'd relied on—health, independence, ability, you name it—with eternal spiritual supports like faith, surrender, and prayer. Those supports enable us to live a life of true freedom, one abounding with spiritual blessing.

Lord, I am tempted to cling to the supports I've erected. When my life crashes, I'm tempted to despair. Please help me to be still and place my trust in You, the great Builder of all lives. Amen.

Day 166
BREATH OF LIFE

He heals the brokenhearted and binds up their wounds
[healing their pain and comforting their sorrow].
PSALM 147:3 AMP

When your life brings disappointment, hurt, and pain that are almost unbearable, remember that you serve the One who heals hearts. He knows you best and loves you most. When the wind is knocked out of you and you feel like there is no oxygen left in the room, let God provide you with the air you need to breathe. Breathe out a prayer to Him, and breathe in His peace and comfort today.

Lord, be my breath of life, today and always. Amen.

Day 167

CAN YOU HEAR ME NOW?

But as for me, I watch in hope for the LORD,
I wait for God my Savior; my God will hear me.
MICAH 7:7 NIV

If there's anything more frustrating than waiting for someone who never shows, it's trying to talk to someone who isn't listening. It's as if they have plugged their ears and nothing penetrates. Mothers are well acquainted with this exercise in futility, as are wives, daughters, and sisters. But the Bible tells us that God hears us when we talk to Him. He shows up when we wait for Him. He will not disappoint us.

When I talk, Lord, I know You will
listen. You will never let me down.

Day 168

QUIET, GENTLE GRACE

*"Let me teach you, because I am humble and gentle
at heart, and you will find rest for your souls."*
MATTHEW 11:29 NLT

Sometimes we keep trying to do things on our own, even though
we don't know what we're doing and even though we're exhausted.
And all the while, Jesus waits quietly, ready to show us the way.
He will lead us with quiet, gentle grace, carrying our burdens for
us. We don't have to try so hard. We can finally rest.

*Jesus, I don't like feeling incompetent and inadequate.
It makes me feel anxious and exhausted. Thank You for Your gentle
teaching and for the strength You provide. Give me Your rest. Amen.*

Day 169

LIFE PRESERVERS

My comfort in my suffering is this:
Your promise preserves my life.
PSALM 119:50 NIV

In the difficulties of life, God is our life preserver. When we are battered by the waves of trouble, we can expect God to understand and to comfort us in our distress. His Word, like a buoyant life preserver, holds us up in the bad times.

But the life preserver only works if you put it on *before* your boat sinks. To get into God's life jacket, put your arms into the sleeves of prayer and tie the vest with biblical words. God will surround you with His love and protection—even if you're unconscious of His presence. He promises to keep our heads above water in the storms of living.

Preserving God, I cling to You as my life preserver.
Keep my head above the turbulent water of life's storms
so I don't drown. Bring me safely to the shore. Amen.

Day 170
BE HAPPY!

Blessed are those who act justly, who always do what is right.
PSALM 106:3 NIV

In the world that we live in today, some might think that a bank error or a mistake on a bill in their favor would be justification for keeping the money without a word. But a true Christ follower would not look at these kinds of situations as good or fortunate events. Our happiness is being honest, doing what is right, because that happiness is the promised spiritual reward. Because we want to be blessed by God, to be a happy follower of Him, we will seek to always do what is right.

Gracious and heavenly Father, thank You for Your blessings each and every day. I am thankful to be Your follower. When I am tempted to do something that would displease You, remind me that You will bless me if I act justly. My happiness will be a much better reward. In Your name, amen.

Day 171

CHERISHED DESIRE

*God our Father loves us. He is kind and has
given us eternal comfort and a wonderful hope.*

2 THESSALONIANS 2:16 CEV

Webster's definition of *hope*: "To cherish a desire with expectation."
In other words, yearning for something wonderful you expect to
occur. Our hope in Christ is not just yearning for something won-
derful, as in "I hope for a sunny beach day." It's a deep trust with
roots that extend from the beginning of time to the infinite future.
Our hope is not just the anticipation of heaven but the expectation
of a fulfilling life walking beside our Creator and best Friend.

*Dear heavenly Father, I want to journey
through life in hopeful expectation—always
anticipating You'll work in wonderful ways!*

Day 172

CAREFUL PLANS

Without good advice everything goes wrong—
it takes careful planning for things to go right.
PROVERBS 15:22 CEV

The Bible reminds us that when we start a new venture, we should not trust success to come automatically. We need to seek out the advice of those we trust. We need to make careful plans. And most of all, we need to seek God's counsel, praying for the grace and wisdom to do things right.

Father, there are so many opportunities for me to grab hold of. It's tempting to dive in headfirst. I desperately need Your counsel. Fill me with Your grace and wisdom. Amen.

Day 173

IS ANYONE LISTENING?

"And I will ask the Father, and He will give you another
Helper (Comforter, Advocate, Intercessor—Counselor,
Strengthener, Standby), to be with you forever."
JOHN 14:16 AMP

The Greek translation for "comfort" is *paraklesis* or "calling near."
When we are called near to someone, we are able to hear her
whisper. It is this very picture scripture paints when it speaks of
the Holy Spirit. God sent the Spirit to whisper to us and to offer
encouragement and guidance, to be our strength when all else
fails. When we pray—when we tell God our needs and give Him
praise—He listens. Then He directs the Spirit within us to speak
to our hearts and give us reassurance.

Our world is filled with noise and distractions. Look for a
place where you can be undisturbed for a few minutes. Take a
deep breath, lift your prayers, and listen. God will speak—and
your heart will hear.

Dear Lord, I thank You for Your care. Help me
to recognize Your voice and to listen well. Amen.

Day 174

DRAWING BACK THE CURTAINS

But whenever someone turns to the Lord, the veil is taken away. . . .
So all of us who have had that veil removed can see and reflect the
glory of the Lord. And the Lord—who is the Spirit—makes us
more and more like him as we are changed into his glorious image.

2 CORINTHIANS 3:16, 18 NLT

Sometimes we feel as though a thick dark curtain hangs between us and God, hiding Him from our sight. But the Bible says that all we have to do is turn our hearts to the Lord and the curtain will be drawn back, letting God's glory and grace shine into our lives. When that happens, we can soak up the light, allowing it to renew our hearts and minds into the image of Christ.

Lord, thank You for removing the veil that hung between us.
Turn my heart to You and draw me to Your light, renewing
my heart and mind and making me more like Christ. Amen.

Day 175

SEEKING AN OASIS

He turns a wilderness into a pool of water,
and a dry land into springs of water.
PSALM 107:35 NASB

The wilderness of Israel is truly a barren wasteland—nothing but rocks and parched sand stretching as far as the distant horizon. The life-and-death contrast between stark desert and pools of oasis water is startling. Our lives can feel parched too. Colorless. Devoid of life. But God has the power to transform desert lives into gurgling, spring-of-water lives. Ask Him to bubble up springs of hope within you today.

When I am feeling parched, Jesus, I trust You'll create a peaceful oasis in my soul. Envelop my spirit in Your hope, Lord.

Day 176

MEANT TO MOVE

We are only foreigners living here on earth for a while,
just as our ancestors were. And we will soon be gone,
like a shadow that suddenly disappears.

1 Chronicles 29:15 CEV

We are not meant to feel too at home in this world. Maybe that is why time is designed to keep us from lingering too long in one place. We are meant to be moving on, making our way to our forever home in heaven. Grace has brought us safe thus far—and grace will lead us home.

Father, the old song says, "This world is not my home,
I'm just passing through..." How I long for the treasure of
my heavenly home. I cannot wait to be there with You. Amen.

Day 177

WHAT IS YOUR REQUEST?

*And pray in the Spirit on all occasions with all
kinds of prayers and requests. With this in mind,
be alert and always keep on praying.*
Ephesians 6:18 niv

Be patient. What we may view as a nonanswer may simply be God saying, *"Wait"* or *"I have something better for you."* He *will* answer. Keep in mind that His ways are not our ways, nor are His thoughts our thoughts.

God knows what He's doing, even when He allows trials in our lives. We might think that saving a loved one from difficulty is a great idea—but God, in His wisdom, may decide that would be keeping them (or us) from an opportunity for spiritual growth. Since we don't know all of God's plans, we must simply lay our requests before Him and trust Him to do what is right. He will never fail us!

*Father God, here are my needs. I lay them at Your
feet, walking away unburdened and assured that
You have it all under control. Thank You! Amen.*

Day 178

FIX YOUR THOUGHTS ON TRUTH

And now, dear brothers and sisters, one final thing.
Fix your thoughts on what is true, and honorable, and
right, and pure, and lovely, and admirable. Think about
things that are excellent and worthy of praise.

Philippians 4:8 nlt

Dig through the scriptures and find truths from God's Word to combat any false message that you may be struggling with. Write them down and memorize them. Here are a few to get started:

God looks at my heart, not my outward appearance (1 Samuel 16:7).

I am free in Christ (1 Corinthians 1:30).

I am a new creation. My old self is gone (2 Corinthians 5:17)!

The next time you feel negativity and false messages slip into your thinking, fix your thoughts on what you know to be true. Pray for the Lord to replace the doubts and negativity with His words of truth.

Lord God, please control my thoughts and help me
set my mind and heart on You alone. Amen.

Day 179

PERMISSION TO MOURN

When I heard this, I sat down and cried. Then for several days,
I mourned; I went without eating to show my sorrow, and I prayed.

NEHEMIAH 1:4 CEV

Bad news. When it arrives, what's your reaction? Do you scream?
Fall apart? Run away? Nehemiah's response to bad news is a model
for us. First, he vented his sorrow. It's okay to cry and mourn. Christians suffer pain like everyone else—only we know the source of
inner healing. Disguising our struggle doesn't make us look more
spiritual. . .just less real. Like Nehemiah, our next step is to turn
to the only true Source of help and comfort.

Thank You for being big enough, God, to carry my sorrow.
I am thankful that with You, I can always be real. . .
sharing my every thought and emotion. And You love me still!

Day 180

WHAT'S REAL

"Then you will experience for yourselves the
truth, and the truth will free you."
JOHN 8:32 MSG

Truth is what is real, while lies are nothing but words. God wants us to experience what is truly real. Sometimes we would rather hide from reality, but grace comes to us through truth. No matter how painful the truth may sometimes seem, it will ultimately set us free.

Jesus, thank You for the truth that sets me free. Help
me to discern truth from lies. Allow me to experi-
ence Your truth in the depth of my being. Amen.

Day 181

HOLD ON!

Let us not become weary in doing good, for at the proper time we will reap a harvest if we do not give up.
GALATIANS 6:9 NIV

When Elijah fled for his life in fear of Jezebel's wrath, depression and discouragement tormented him. Exhausted, he prayed for God to take his life, and then he fell asleep. When he awoke, God sent an angel with provisions to strengthen his weakened body. Only then was he able to hear God's revelation that provided the direction and assistance he needed.

God hears our pleas even when He seems silent. The problem is that we cannot hear Him because of physical and mental exhaustion. Rest is key to our restoration.

Just when the prophet thought he could go on no longer, God provided the strength, peace, and encouragement to continue. He does the same for us today. When we come to the end of our rope, God ties a knot. And like He did for Elijah, God will do great things in and through us, if we will just hold on.

*Dear Lord, help me when I can no longer help myself.
Banish my discouragement and give me the rest and
restoration I need so that I might hear Your voice. Amen.*

Day 182
SIMPLE THINGS

In him our hearts rejoice, for we trust in his holy name.
PSALM 33:21 NIV

God knows all the simple pleasures you enjoy—and He created them for your delight. When the simple things that can come only by His hand fill you with contentment, He is pleased. He takes pleasure in you. You are His delight. Giving you peace, comfort, and a sense of knowing that you belong to Him is a simple thing for Him. Take a moment today and step away from the busyness of life. Take notice of and fully experience some of those things you enjoy most. Then share that special joy with Him.

Lord, thank You for the simple things that bring pleasure to my day. I enjoy each gift You've given me. I invite You to share those moments with me today. Amen.

Day 183

PEBBLES

"I will give you a new heart and put a new spirit
within you; and I will remove the heart of stone
from your flesh and give you a heart of flesh."
Ezekiel 36:26 nasb

So many things can harden our hearts: overwhelming loss; shattered dreams; even scar tissue from broken hearts, disillusionment, and disappointment. To avoid pain, we simply turn off feelings. Our hearts become petrified rock—heavy, cold, and rigid. But God can crack our hearts of stone from the inside out and replace that miserable pile of pebbles with soft, feeling hearts of flesh. The amazing result is a brand-new, hope-filled spirit.

God, please take my hard heart and make it soft again. Renew my
spirit with Your hope. Transform me from the inside out! Amen.

Day 184

GROWING IN GRACE

This is my prayer for you: that your love will grow more and more; that you will have knowledge and understanding with your love.

PHILIPPIANS 1:9 NCV

God wants us to be spiritually mature. He wants us to love more deeply, and at the same time, He wants us to reach deeper into wisdom and understanding. This is not something we can accomplish in our own strength with our own abilities. Only God can make us grow in grace.

God, I long for my love to grow more and more. Fill me with knowledge and understanding; help me to lean into Your grace that brings growth. Amen.

Day 185

SILENCE

He was oppressed, and he was afflicted, yet he opened not his mouth; like a lamb that is led to the slaughter, and like a sheep that before its shearers is silent, so he opened not his mouth.

ISAIAH 53:7 ESV

Jesus' silence can teach us important lessons. Underneath His silence was an implicit trust in His Father and His purposes. Christ knew who He was and what He had come to do.

Perhaps He was praying silently as He stood before Pilate. It is often in the stillness of our lives that we hear God best. When we take time to think, meditate on scripture, pray, and reflect, we find that we can indeed hear the still, small voice. Many of us avoid quiet and solitude with constant noise and busyness. But important things happen in the silence. The Father can speak; we can listen. We can speak, knowing He is listening. Trust is built in silence, and confidence strengthens in silence.

Lord Jesus, help me to learn from Your silence. Help me to trust You more so that I don't feel the need to explain myself. Give me the desire and the courage to be alone with You and learn to hear Your voice. Amen.

Day 186

WHISPERS IN THE WIND

Then Jesus told him, "Because you have seen me, you have believed;
blessed are those who have not seen and yet have believed."

JOHN 20:29 NIV

We can't see God. We can't take Him by the hand or even converse with Him face-to-face like we do a friend. But we still know He is present in our lives because we can experience the effects. God moves among His people, and we can see it. God speaks to His people, and we can hear the still, small voice. And, just like we can feel the wind across our cheeks, we can feel God's presence. We don't need to physically see God to know that He exists and that He's working.

You are like the wind, Lord. Powerful and fast moving,
soft and gentle. We may not see You, but we can sense You.
Help us to believe, even when we can't see. Amen.

Day 187

DO A LITTLE DANCE

*Then Miriam. . .took a tambourine and led all the women
as they played their tambourines and danced.*
EXODUS 15:20 NLT

Can you imagine the enormous celebration that broke out among
the children of Israel when God miraculously saved them from
Pharaoh's army? Even dignified prophetess Miriam grabbed her
tambourine and cut loose with her girlfriends. Despite adverse
circumstances, she heard God's music and did His dance. Isn't that
our goal today? To hear God's music above the world's cacophony
and do His dance as we recognize everyday miracles in our lives?

*Make me aware of Your everyday miracles, Father. Help me to
listen closely for Your music so I can join in the dance. Amen.*

Day 188

GRACE MULTIPLIED

*Honor the LORD with your wealth and with
the best part of everything you produce.*
PROVERBS 3:9 NLT

We connect the word *wealth* with money, but long ago the word meant "happiness, prosperity, well-being." If you think about your wealth in this light, then the word encompasses far more of your life. Your health, your abilities, your friends, your family, your physical strength, and your creative energy—all of these are parts of your true wealth. Grace brought all of these riches into your life, and when you use them to honor God, grace is multiplied still more.

*Father, when I consider all the good things You
have given me, I am rich beyond belief. Help me
to graciously honor You with my wealth. Amen.*

Day 189

FOLLOW THE LORD'S FOOTSTEPS

"Come, follow me," Jesus said, "and I will send you out to fish for people."
MATTHEW 4:19 NIV

Jesus asked His disciples to follow Him, and He asks us to do the same. It sounds simple, but following Jesus can be a challenge. Sometimes we become impatient, not wanting to wait upon the Lord. We run ahead of Him by taking matters into our own hands and making decisions without consulting Him first. Or perhaps we aren't diligent to keep in step with Him. We fall behind, and soon Jesus seems so far away.

Following Jesus requires staying right on His heels. We need to be close enough to hear His whisper. Stay close to His heart by opening the Bible daily. Allow His Word to speak to your heart and give you direction. Throughout the day, offer up prayers for guidance and wisdom. Keep in step with Him, and His close presence will bless you beyond measure.

*Dear Lord, grant me the desire to follow You.
Help me not to run ahead or lag behind. Amen.*

Day 190

STANDING IN THE LIGHT

*Though I have fallen, I will rise. Though I sit in
darkness, the LORD will be my light.*

MICAH 7:8 NIV

We may fall down, but God will lift us up. We may feel surrounded
by darkness on every side, but He will be our light, guiding the
way, showing us which step to take next. No matter where we are,
what we've done, or what we're facing, God is our Rescuer, our
Savior, and our Friend.

Satan wants to convince us that we have no hope, no future.
But God's children always have a future and a hope. . .we are
cherished, and we belong to Him.

*Dear Father, thank You for giving me confidence in
a future filled with good things. When I'm down,
remind me to trust in Your love. Thank You for lift-
ing me out of darkness to stand in Your light. Amen.*

Day 191

UP IS THE ONLY OUT

Let them lie face down in the dust,
for there may be hope at last.
LAMENTATIONS 3:29 NLT

The Old Testament custom for grieving people was to lie prostrate and cover themselves with ashes. Perhaps the thought was that when you're wallowing in the dust, at least you can't descend any further. There's an element of hope in knowing that there's only one way to go: up. If a recent loss has you sprawled in the dust, know that God doesn't waste pain in our lives. He will use it for some redeeming purpose.

Help me to recognize the purpose in my pain,
Father. I know You have a plan for my life—and
that Your plans are good. I trust You, Father. Amen.

Day 192

BUILDING GOD'S KINGDOM

*"I have filled him with the Spirit of God in
wisdom and skill, in understanding and intelligence,
in knowledge, and in all kinds of craftsmanship."*

EXODUS 31:3 AMP

Your abilities, your intelligence, your knowledge, and your talents
are all gifts of grace from God's generous Spirit. But without
wisdom, the ability to see into the spiritual world, none of these
gifts is worth very much. Wisdom is what fits together all of the
other pieces, allowing us to use our talents to build God's spiritual
kingdom.

*Lord, I am so grateful for the filling of Your Spirit and
for the gift of wisdom. Thank You for allowing me to be
involved with the building of Your kingdom. Amen.*

Day 193

A DIFFERENT CUP TO FILL

O God, thou art my God; early will I seek thee.
PSALM 63:1 KJV

King David resided over the nation of Israel and all that that entailed. Yet he found time to seek the counsel, mercy, and direction of God daily. The more responsibilities he assumed, the more he prayed and meditated on God's precepts. Well before David was inundated with worldly concerns, nagging obligations, and his administrative duties, the Bible suggests that he sought the Lord in the early morning hours.

If the king of Israel recognized his need to spend time with God, how much more should we? When we seek our heavenly Father before daily activities demand our attention, the Holy Spirit regenerates our spirits, and our cups overflow.

Dear Lord, I take this time to pray and spend time with
You before I attend to daily responsibilities. Fill my cup
with the presence and power of Your Spirit. Give me
the wisdom and direction I need today. Amen.

Day 194

REFRESHMENT IN DRY TIMES

*"The grass withers and the flowers fall,
but the word of our God endures forever."*
ISAIAH 40:8 NIV

Sometimes our lives feel just like the grass—dry and listless. Maybe we're in a season where things seem to stand still, and we've tried everything to change our circumstances for the better to no avail. It is during those times that we need to remember the faithfulness of God and the permanence of His Word. His promises to us are many and true! God will never leave us or forsake us; and He will provide for, love, and protect us. And, just like the drought, eventually our personal dry times will give way to a time of growth, refreshment, and beauty.

Dear Lord, help me to remember Your love during difficult times of dryness. Even though it's sometimes hard to hear Your voice or be patient during hard times, please remind me of Your many promises, and remind me to stand firmly on them. You are everything I need and the refreshment I seek. Praises to my Living Water! Amen.

Day 195

HE'S GOT YOUR BACK

"But we will devote ourselves to prayer
and to the ministry of the word."

ACTS 6:4 NASB

As busy women, we've found out the hard way that we can't do everything. Heaven knows we've tried, but the truth has found us out: Superwoman is a myth. So we must make priorities and focus on the most important. Prayer and God's Word should be our faith priorities. If we only do as much as we can do, then God will take over and do what only He can do. He's got our backs, girls!

I know I can't do it all, God. I find comfort in knowing that
if I put my faith in You wholeheartedly, You will always help
me prioritize my to-do list and get the R & R I need.

Day 196

HEAVEN'S PERSPECTIVE

Always give yourselves fully to the work of the Lord,
because you know that your labor in the Lord is not in vain.

1 CORINTHIANS 15:58 NIV

You may feel sometimes as though all of your hard work comes to nothing. But if your work is the Lord's work, you can trust Him to bring it to fulfillment. You may not always know what is being accomplished in the light of eternity, but God knows. And when you look back from heaven's perspective, you will be able to see how much grace was accomplished through all of your hard work.

God, when I don't see results, I sometimes get discouraged
in my work for You. Help me to remember that You
are busy doing things I cannot see. Amen.

Day 197

NEAR AT HAND

Quiet down before GOD, be prayerful before him.
PSALM 37:7 MSG

It's not easy to be quiet. Our world is loud, and the noise seeps into our hearts and minds. We feel restless and jumpy, on edge. God seems far away. But God is always near at hand, no matter how we feel. When we quiet our hearts, we will find Him there, patiently waiting, ready to show us His grace.

Lord, when my heart is restless and jumpy, remind me that You are near, waiting to comfort me with Your love. Quiet me with Your nearness. Show me Your grace. Amen.

Day 198

THE END OF YOUR ROPE

*Do not be far from me, for trouble
is near and there is no one to help.*

PSALM 22:11 NIV

Jesus reaches down and wraps you in His loving arms when you call to Him for help. The Bible tells us that He is close to the brokenhearted (Psalm 34:18). We may not have the answers we are looking for here in this life, but we can be sure of this: God sees our pain and loves us desperately. Call to Him in times of trouble. If you feel that you're at the end of your rope, look up! His mighty hand is reaching toward you.

*Heavenly Father, I feel alone and afraid. Surround me
with Your love, and give me peace and joy. Amen.*

Day 199

SPROUTS

*"For there is hope for a tree, when it is
cut down, that it will sprout again."*

JOB 14:7 NASB

Have you ever battled a stubborn tree? You know, one you can saw off at the ground but the tenacious thing keeps sprouting new growth from the roots? You have to admire the resiliency of that life force, struggling in its refusal to give up. That's hope in a nutshell, sisters. We must believe, even as stumps, that we will eventually become majestic, towering evergreens if we just keep sending out those sprouts.

*Father God, help me continue to hope that I will
grow into the woman You created me to be—
just like the majestic, towering evergreen.*

Day 200

BLESSING OTHERS

"Bless those who curse you. Pray for those who hurt you."
LUKE 6:28 NLT

Not only does God bless us, but we are called to bless others. God wants to show the world His grace through us. He can do this when we show our commitment to make God's love real in the world around us through our words and actions, as well as through our prayer life. We offer blessings to others when we greet a scowl with a smile, when we refuse to respond to angry words, and when we offer understanding to those who are angry and hurt.

God, I sometimes forget that the world is watching.
I long to shine Your light to everyone I see. Help me to
bestow blessings on others, even when they hurt me. Amen.

Day 201

PERFECT PRAYERS

"Pray, then, in this way: 'Our Father. . .'" Out of the
depths [of distress] I have cried to You, O LORD.
MATTHEW 6:9 AMP; PSALM 130:1 AMP

How many times have we made prayer a mere religious exercise, performed best by the "holy elite," rather than what it really is— conversation with God our Father?

Just pour out your heart to God. Share how your day went. Tell Him your dreams. Ask Him to search you and reveal areas of compromise. Thank Him for your lunch. Plead for your family and friends' well-being. Complain about your car. . . . Just talk with Him. Don't worry how impressive (or unimpressive!) you sound.

Talk with God while doing dishes, driving the car, folding laundry, eating lunch, or kneeling by your bed. Whenever, wherever, whatever—tell Him. He cares!

Don't allow this day to slip away without talking to your Father. No perfection required.

Father God, what a privilege it is to unburden my
heart to You. Teach me the beauty and simplicity
of simply sharing my day with You. Amen.

Day 202

OH THE DEEP,
DEEP LOVE OF JESUS

*I pray that out of his glorious riches he may strengthen you
with power through his Spirit in your inner being, so that
Christ may dwell in your hearts through faith. And I pray
that you, being rooted and established in love, may have power,
together with all the Lord's holy people, to grasp how wide
and long and high and deep is the love of Christ.*

EPHESIANS 3:16–18 NIV

What an amazing picture. That He should care for us in such a
way is almost incomprehensible. Despite our shortcomings, our
sin, He loves us. It takes a measure of faith to believe in His love.
When you feel a nagging thought of unworthiness, of being un-
lovable, trust in the Word and sing a new song. For His love is
deep and wide.

Lord, thank You for loving me, even when I'm unlovable. Amen.

Day 203
MAKEOVER

Since I was worse than anyone else, God had mercy on me and let me be an example of the endless patience of Christ Jesus.
1 TIMOTHY 1:16 CEV

Saul was a Jesus hater. He went out of his way to hunt down believers to torture, imprison, and kill. Yet Christ tracked him down and confronted him in a blinding light on a dusty road. Saul's past no longer mattered. Previous sins were forgiven and forgotten. He was given a fresh start. A life makeover. We too are offered a life makeover. Christ offers to create a beautiful new image of Himself in us, unblemished and wrinkle-free.

Thank You for new beginnings and fresh starts, God. You have erased my sins, and now I walk free in Your unending grace!

Day 204

SOUND ADVICE

Without good direction, people lose their way; the more
wise counsel you follow, the better your chances.

PROVERBS 11:14 MSG

Often God makes use of other people when He wants to guide you.
His grace flows to you through others' experiences and wisdom.
Keep your ears open for His voice speaking to you through the
good advice of those you trust.

Lord, even when I am inclined to run off on my own, help me
to seek direction from the wise people in my life. Amen.

Day 205

ANXIETY CHECK!

Do not be anxious about anything, but in every situation, by prayer and petition, with thanksgiving, present your requests to God.
PHILIPPIANS 4:6 NIV

Twenty-first-century women are always checking things. A bank balance. Email. Voice messages. The grocery list. And, of course, that never-ending to-do list. We routinely get our oil, tires, and brake fluid checked. And we wouldn't think of leaving home for the day without checking our appearance in the mirror. We even double-check our purses, making sure we have the essentials—lipstick, mascara, and cell phone.

When was the last time you did an anxiety check? Days? Weeks? Months? Chances are, you're due for another. After all, we're instructed not to be anxious about anything. Instead, we're to present our requests to God with thanksgiving in our hearts. We're to turn to Him in prayer so that He can take our burdens. Once they've lifted, it's bye-bye anxiety!

Father, I get anxious sometimes. And I don't always remember to turn to You with my anxiety. In fact, I forget to check for anxiety at all. Today I hand my anxieties to You. Thank You that I can present my requests to You. Amen.

Day 206

I GROW WEARY

But those who wait for the LORD [who expect, look for, and hope in Him] will gain new strength and renew their power; they will lift up their wings [and rise up close to God] like eagles [rising toward the sun]; they will run and not become weary, they will walk and not grow tired.

ISAIAH 40:31 AMP

As long as we are warring inside, we will not find rest. We must find out what Jesus wants for our lives and then obey. Feasting on His Word and learning more about Him will give us the direction we need and the ability to trust. It is only when we understand our salvation and surrender that we can come to Him, unencumbered by guilt or fear, and lay our head on His chest. Safe within His embrace, we can rest. We will be as a well-watered garden, refreshed and blessed by our loving Creator.

Father, I am weary and need Your refreshing
Spirit to guide me. I trust in You. Amen.

Day 207
SNIPPETS OF HOPE

I also pray that you will understand the incredible
greatness of God's power for us who believe him.
EPHESIANS 1:19 NLT

Daydreams are snippets of hope for our souls. Yearnings for something better, something more exciting, something that lifts our spirits. Some dreams are mere fancy, but others are meant to last a lifetime because God embedded them in our hearts. It's when we lose sight of those dreams that hope dies. But God offers us access to His almighty power—the very same greatness that brought His Son back from the dead. What greater hope is there?

Thank You for the dreams You wove into my heart, Father God.
Please help me keep those dreams for the future alive. Amen.

Day 208
CHRISTLIKE

Don't sin by letting anger control you. Think
about it overnight and remain silent.
PSALM 4:4 NLT

A disciple must practice certain skills until she becomes good at them. As Christ's disciples, we are called to live like Him. The challenge of that calling is often hardest in life's small, daily frustrations, especially with the people we love the most. But as we practice saying no to anger, controlling it rather than allowing it to control us, God's grace helps us develop new skills, even ones we never thought possible!

God, teach me the difference between sinful anger
and righteous anger. Help me to push the PAUSE
button when I get angry so I can listen to You. Amen.

Day 209

A FRESH EXPERIENCE

Because of the LORD's great love we are not
consumed, for his compassions never fail. They
are new every morning; great is your faithfulness.
LAMENTATIONS 3:22–23 NIV

God starts out His day offering renewed compassion to His children. No matter what trials, difficulties, and sins yesterday brought, the morning ushers in a fresh experience, a brand-new beginning for believers who seek His forgiveness. All you have to do is accept the gift.

Are you burdened from yesterday's stress? Are the worries of tomorrow keeping you awake at night? Consider the dawning of the day as an opportunity to begin anew with our heavenly Father. Seek Him in the morning through studying His Word and through prayer, embracing His compassion to be a blessing to others throughout your day.

Father, Your promise of never-ending compassion for me is amazing!
I never want to take for granted the grace You offer every day. I'm
so undeserving, but still You give and give and give. Please help
me to show mercy to others the same way You do to me. Amen.

Day 210
REAP IN JOY!

Remember this: Whoever sows sparingly will also reap sparingly, and whoever sows generously will also reap generously.
2 Corinthians 9:6 niv

Each of us wants to feel appreciated, and we like to deal with a friendly person. Have you ever worked with a person who seemed to have a perpetually bad attitude? You probably didn't feel particularly encouraged after an encounter with this coworker. Yes, sometimes things go wrong, but your attitude in the thick of it is determined by your expectations. If you expect things to turn out well, you'll generally have a positive mental attitude. Treat everyone with genuine kindness, courtesy, and respect, and that is what will be reflected back to you.

Heavenly Father, help me plant the seeds of patience, love, compassion, and courtesy in all those I come in contact with. Please let me make an eternal difference in these people's lives. I want to joyfully reap a rich harvest for Your kingdom. Amen!

Day 211
EASY AS ABC

God has done all this, so that we will look for him and
reach out and find him. He isn't far from any of us.
ACTS 17:27 CEV

God is near. But we must reach out for Him. There's a line that we choose to cross, a specific action we take. We can't ooze into the kingdom of God; it's an intentional decision. It's simple, really—as simple as ABC. *A* is Admitting we're sinful and in need of a Savior. *B* is Believing that Jesus died for our sins and rose from the grave. *C* is Committing our lives to Him. Life everlasting is then ours.

God, You are always within reach. For that,
I am so very thankful. I look forward to
eternal life in Your presence. Amen.

Day 212
BACK TO GOD

*My dear brothers and sisters, always be willing to listen
and slow to speak. Do not become angry easily, because an-
ger will not help you live the right kind of life God wants.*

<small>JAMES 1:19–20 NCV</small>

Our feelings are gifts from God, and we should never be ashamed
of them. Instead, we need to offer them all back to God, both
our joys and our frustrations. When we give God our anger, our
irritation, our hurt feelings, and our frustrations, we make room
in our hearts to truly hear what others are saying.

*Father, as uncomfortable as my feelings can be sometimes,
thank You for what they teach me. Help me to trust You
with all my feelings so I can be a good listener. Amen.*

Day 213

LEARNING AS WE GROW

*"But I am only a little child and do not
know how to carry out my duties."*

1 Kings 3:7 niv

When King David died, Solomon became the king of Israel. Just like a child who does not yet know how to put away his toys, Solomon confesses that he does not know how to carry out his duties as king of Israel. Instead of sitting down on his throne in despair, though, Solomon calls on the name of the Lord for help.

As Christians, we are sometimes like little children. We know what our duties as Christians are, but we do not know how to carry them out. Just like Solomon, we can ask God for help and guidance in the completion of our responsibilities. God hears our prayers and is faithful in teaching us our duties, just as He was faithful to Solomon in teaching him his.

Dear Lord, thank You for being willing to teach me my Christian responsibilities. Help me to learn willingly and eagerly. Amen.

Day 214

THE WORD FOR EVERY DAY

*As for God, his way is perfect; the word of the Lord is
tried: he is a buckler to all them that trust in him.*

2 Samuel 22:31 kjv

God's Word is such an incredible gift, one that goes hand in hand
with prayer. It's amazing, really, that the Creator of the universe
gave us the scriptures as His personal Word to us. When we're
faithful to pick up the Word, He is faithful to use it to encour-
age us. Reading and praying through scripture is one of the keys
to finding and keeping our sanity, peace, and joy.

*God, thank You for Your gifts of the holy scriptures and
sweet communion with You through prayer. Amen.*

Day 215
AIM HIGH

My aim is to raise hopes by pointing
the way to life without end.
TITUS 1:2 MSG

No woman is an island. We're more like peninsulas. Although we sometimes feel isolated, we're connected to one another by the roots of womanhood. We're all in this together, girls. As we look around, we can't help but see sisters who need a hand, a warm smile, a caring touch. And especially hope. People need hope, and if we know the Lord—the source of eternal hope—then it's up to us to point the way through love.

I have so many women in my life who are constant reminders
of the one eternal source of hope—YOU, Father God. Thank
You for placing these beautiful women in my life.

Day 216

WHOLLY AND COMPLETELY

"Forgive others, and you will be forgiven."
LUKE 6:37 NLT

The words *forgive* and *pardon* come from very old words that mean "to give up completely and wholeheartedly." When we forgive others, we totally give up our rights to feel we've been injured or slighted. And in return, God's grace totally fills the gaps left behind when we let go of our own selfishness. As we give ourselves wholeheartedly to others, God gives Himself completely to us.

God, help me to forgive others so that nothing hinders me from fully receiving the gift of Your forgiveness. Thank You for Your grace that pours over me. Amen.

Day 217
RECONCILED TO GOD

Ezra wept, prostrate in front of The Temple of God. As he
prayed and confessed, a huge number of the men, women,
and children of Israel gathered around him. All the people
were now weeping as if their hearts would break.

EZRA 10:1 MSG

Satan loves to remind us of our sins to make us feel guilty. He adores it when we wallow in them. But God never intended for us to do that. Instead, God wants us to confess our sins—daily, or hourly if need be!—receive His forgiveness, and move on to live with renewed fervor.

What sins have separated us from God today? Let's draw near the throne of grace so we can receive His pardon. He longs for us to come near to Him, and He will cover us with Jesus' robe of righteousness so that we don't have to feel guilt or shame anymore.

Lord, forgive me for the sins I've committed today.
Make me ever aware of Your grace and forgiveness
so that I may share Your love with others. Amen.

Day 218

SEEING CLEARLY

Turning your ear to wisdom and applying your heart to understanding—indeed, if you call out for insight and cry aloud for understanding, and if you look for it as for silver and search for it as for hidden treasure, then you will understand the fear of the LORD and find the knowledge of God.
PROVERBS 2:2–5 NIV

Frustration and stress can keep us from clearly seeing the things that God puts before us. Time spent in prayer and meditation on God's Word can often wash away the dirt and grime of the day-to-day and provide a clear picture of God's intentions for our lives. Step outside the pressure and into His presence, and get the right focus for whatever you're facing today.

Lord, help me to avoid distractions
and keep my eyes on You. Amen.

Day 219

FILL 'ER UP

"What strength do I have, that I should still hope?"
Job 6:11 niv

Run, rush, hurry, dash: a typical American woman's day. It's easy to identify with David's lament in Psalm 22:14 (nasb): "I am poured out like water. . .my heart is like wax; it is melted within me." Translation: I'm pooped; I'm numb; I'm drained dry. When we are at the end of our strength, God doesn't want us to lose hope of the refilling He can provide if we only lift our empty cups to Him.

*Fill me up, Lord! I need Your heavenly presence. . .
Your strength. . .Your comfort. Thank You for the
hope You provide in the dailiness of life!*

Day 220

OUR COMPANION

Our Lord, you are the friend of your worshipers,
and you make an agreement with all of us.

PSALM 25:14 CEV

God is our Friend. He is our Companion through life's journey; He is the One who always understands us; and no matter what we do, He always accepts us and loves us. What better agreement could we ever have with anyone than what we have with God?

Father, thank You for being my Friend, my Companion, my Comfort. Thank You for the everlasting covenant You have made with me. I am grateful to be Your child. Amen.

Day 221

JONAH'S PRAYER

"In my distress I called to the LORD, and he answered me.
From deep in the realm of the dead I called
for help, and you listened to my cry."

JONAH 2:2 NIV

Jonah's prayer is distinctive because he's praying from the belly of a large fish—a seemingly hopeless situation. The response you might expect is "Lord, get me out of here!" Instead, Jonah praises God for listening to and answering him! He prays with gratitude and praise as well as with contrition.

Jonah's example is helpful to Christians today. He teaches us that even in our worst situations, we need to approach God with both repentance and thanksgiving. No matter our experiences, we serve a powerful God—One who deserves all honor and praise.

Dear Lord, thank You for hearing my prayers.
Thank You for having mercy on me. Amen.

Day 222

JUST LOOK FOR HIM

"I love all who love me. Those who
search will surely find me."
PROVERBS 8:17 NLT

Scripture tells us that God loves those who love Him and that if
we search for Him, we will surely find Him. One translation of the
Bible says it this way: "Those who seek me early and diligently will
find me" (Proverbs 8:17 AMP). Seek God in all things and in all
ways. Search for Him in each moment of every day you are blessed
to walk on this earth. He is found easily in His creation and in His
Word. He is with you. Just look for Him. He wants to be found!

Father in heaven, thank You for Your unfailing
love for me. Help me to search for You diligently.
I know that when I seek, I will find You. Amen.

Day 223

LAUGH A RAINBOW

*"When I see the rainbow in the clouds, I will
remember the eternal covenant between God
and every living creature on earth."*
GENESIS 9:16 NLT

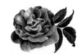

Ever feel like a cloud is hanging over your head? Sometimes the cloud darkens to the color of bruises, and we're deluged with cold rain that seems to have no end. When you're in the midst of one of life's thunderstorms, tape this saying to your mirror: Cry a river, laugh a rainbow. The rainbow, the symbol of hope that God gave Noah after the flood, reminds us even today that every storm will eventually pass.

*The rainbows You place in the sky after a storm are lovely
reminders of the hope we have in You, God. Because of You,
I know that the storms of life are only temporary. . .
and You will bring beauty from the storms.*

Day 224

THE NEXT OASIS

*The LORD will always guide you and provide good things
to eat when you are in the desert. He will make you
healthy. You will be like a garden that has plenty
of water or like a stream that never runs dry.*

ISAIAH 58:11 CEV

God wants you to be healthy—not just physically, but emotionally, intellectually, and spiritually as well. He wants to fill your life full of all the things you truly need. The life He wants for you is not dry and empty and barren. Instead, it is lush and full of delicious things to nourish you. We all have to cross life's deserts sometimes, but even then God will supply what you need to reach the next oasis He has waiting.

*Lord, this life can feel like an incredibly long journey,
especially when I am in the desert. Sustain and strengthen
me with the promises of Your Word. Amen.*

Day 225

CHRIST IS INVOLVED

Being confident of this very thing, that he which hath begun a
good work in you will perform it until the day of Jesus Christ.
PHILIPPIANS 1:6 KJV

Christ wants you to grow in your faith. He wants to help you flee the temptations that you will inevitably face. He wants to give you strength to be joyful even as you go through trials. His ultimate desire is to help you become more like Him.

Do you allow Jesus to be as involved in your life as He wants to be? Unfortunately, a lot of people accept Him in order to get into heaven, but then they want little more to do with Him. Why not choose now to let Him be a part of everything you do and every decision you make? Go to Him in prayer. Seek answers from His Word and from the Holy Spirit. He will do a great work in your life. He will be faithful to complete what He started in you—and you will become like Him.

Dear Jesus, thank You for wanting to help me be like
You. Thank You for being involved in my life and
not leaving me to my own designs. Amen.

Day 226

WHEN YOU GIVE YOUR LIFE AWAY

*Which of you, intending to build a tower, sitteth not down first,
and counteth the cost, whether he have sufficient to finish it?*

LUKE 14:28 KJV

Every person has the same amount of life each day. What matters is how you spend it. It's easy to waste your day doing insignificant things, leaving little time for God. The most important things in life are eternal endeavors. Spending time in prayer to God for others. Giving your life to building a relationship with God by reading His Word and growing in faith. Sharing Christ with others and giving them the opportunity to know Him. These are things that will last. What are you spending your life on? What are you getting out of what you give yourself to each day?

*Heavenly Father, my life is full. I ask that You give me wisdom
and instruction to give my life to the things that matter
most. The time I have is precious and valuable. Help
me to invest it wisely in eternal things. Amen.*

Day 227

HOW SHOULD I TALK TO GOD?

"This, then, is how you should pray: 'Our Father in heaven, hallowed be your name, your kingdom come, your will be done, on earth as it is in heaven. Give us today our daily bread. And forgive us our debts, as we also have forgiven our debtors. And lead us not into temptation, but deliver us from the evil one.'"

MATTHEW 6:9–13 NIV

Jesus gave us an example of how to pray in His famous petition that was recorded in Matthew 6:9–13. We don't need to suffer with an anxious heart or feel ensnared by this world with no one to hear our cry for help. We can talk to God, right now, and He will listen. The act of prayer is as simple as launching a boat into the Sea of Galilee, but it's as miraculous as walking on water.

God, how wonderful it is that You hear me when I call out to You, and that You answer with exactly what I need. Amen.

Day 228

WONDERFUL THINGS

*Everything God made is waiting with excitement
for God to show his children's glory completely.*

ROMANS 8:19 NCV

Some days it's hard to feel very optimistic. We listen to the evening news and hear story after story about natural disasters and human greed. God doesn't want us to be ostriches, hiding our heads in the sand, refusing to acknowledge what's going on in the world. But He also wants us to believe that the future is full of wonderful things He has planned. The whole world is holding its breath, waiting for God's wonderful grace to reveal itself.

*God, I cannot even begin to comprehend the riches You have
in store for us, Your children. When I am discouraged,
lift my head and remind me of Your promise. Amen.*

Day 229

FREEDOM

Exercise your freedom by serving God, not by breaking the rules. Treat everyone you meet with dignity. Love your spiritual family. Revere God. Respect the government.

1 PETER 2:16–17 MSG

Paul tells us in 1 Corinthians 10:23 (NIV) that "'I have the right to do anything,' you say—but not everything is beneficial. 'I have the right to do anything'—but not everything is constructive." We must be careful and responsible with our freedom. Paul warns us not to cause anyone to stumble and that everything we do should be done to the glory of God.

Are you a responsible Christian? Is there anything in your life that is causing someone in your life to stumble? Could it be the television shows you watch, the types of movies you frequent, or maybe even your spending habits? Take this to the Lord in prayer and ask Him to search your heart and show you anything that may be hindering another person in her walk with Christ.

Father, help me to be responsible with my freedom. Please help me to change anything in my life that might be causing someone else to stumble. Amen.

Day 230

UNFAILING LOVE

I will instruct you and teach you in the way you should go;
I will counsel you with my loving eye on you. . . . Many
are the woes of the wicked, but the LORD's unfailing
love surrounds the one who trusts in him.

PSALM 32:8, 10 NIV

God's love surrounds us always—if we trust in Him. Have you put your complete trust in the Lord? If not, then open your heart to Him and ask Him to become the Lord of your life. Jesus is standing at the door of your heart, ready to come in when you respond (Revelation 3:20). Or maybe you've already accepted Christ as your Savior, but you're not really sure if He can be trusted. Know that He has been faithful to His children through all generations and that He is working out every circumstance in your life for your own good (Romans 8:28).

Father God, I praise You for Your unfailing love. Continue to
counsel me and lead me in the way I should go. Thank You for
watching over me. Help me trust You completely. Amen.

Day 231

GOD IS DOING SOMETHING NEW

"See, I am doing a new thing! Now it springs up;
do you not perceive it? I am making a way in the
wilderness and streams in the wasteland."

ISAIAH 43:19 NIV

Imagine that desert, dry and barren—with no hope of even a
cactus flower to bloom—suddenly coming to life with bubbling
pools of pure water. That is what God promises us. He is doing
something new in our lives. He is making a path through what
feels impassable, and He will command a stream to flow through
the wilderness of our pasts, places where we had only known the
wasteland of sin and a landscape of despair. Have faith and bring
your empty buckets to the stream.

Father, thank You for Your provision, hope, and joy. Without
You, life is dry and hostile. Come into my life and quench my
thirst. You are the only one who can fulfill me. Amen.

Day 232

THE ENTIRE PACKAGE

He makes the whole body fit together perfectly. As each part
does its own special work, it helps the other parts grow, so that
the whole body is healthy and growing and full of love.

EPHESIANS 4:16 NLT

God has a holistic perspective on health. He sees your body, soul, heart, and mind, and He wants each part of you to be strong and fit. He looks at our world in the same way, longing to heal the entire package—society, the environment, and governments. He wants His body on earth, the Church, to be whole and strong as well. Health pours out of Him, a daily stream of grace on which we can rely for each aspect of life.

Lord, I am grateful You have enabled me to be
a part of Your body—the Church. Help me to do
my part so that all of us can grow. Amen.

Day 233

PRAYING FOR LOVED ONES

*"Therefore I tell you, whatever you ask for in prayer,
believe that you have received it, and it will be yours."*

MARK 11:24 NIV

One of the best things a woman can do for her loved ones is pray for them. And while we don't find one simple formula for effective prayer in the Bible, *how* we pray may be just as important as *what* we pray.

Do we beseech God with faith, believing that He can do anything? Or do we pray with hesitation, believing that nothing is going to change? God is honored and willing to work when we pray with faith.

The most beneficial times of prayer often come when we make time to listen to God, not just talk "at" Him. He can give us wisdom and insights we would never come up with on our own.

Though we can't always see it, He is at work, in our loved ones' hearts and in ours.

Lord, thank You for Your concern for my friends and family members. I know You love them even more than I do. Amen.

Day 234

THOU SHALT NOT WORRY!

*"Do not worry about tomorrow, for tomorrow will
worry about itself. Each day has enough trouble of its own."*
MATTHEW 6:34 NIV

What if the Lord had written an eleventh commandment: "Thou shalt not worry." In a sense, He did! He commands us in various scriptures not to fret. So cast your anxieties on the Lord. Give them up! Let them go! Don't let worries zap your strength and your joy. Today is a gift from the Lord. Don't sacrifice it to fears and frustrations! Let them go. . .and watch God work!

*Father God, lift all anxiety from my heart and make my spirit
light again. I know that I can't do it on my own. But with You,
I can let go. . .and watch You work! I praise You, God! Amen.*

Day 235

DIVINE IMAGININGS AND SUBLIME ASPIRATIONS

He has made everything beautiful in its time.
He has also set eternity in the human heart.

ECCLESIASTES 3:11 NIV

Let's join hands. Let's celebrate. God has made everything beautiful in its time. He has also set eternity in the human heart. Never sit in the gutter when the steps of paradise are at your feet! So widen your scope. See beauty in all things great and small. Soar free. Imagine beyond the ordinary. Love large. Forgive lavishly. Hope always. Expect a miracle.

Father, give me a contagious enthusiasm for life.
You have given me everything I need. Amen.

Day 236
BREATHING

In certain ways we are weak, but the Spirit is here to help us.
For example, when we don't know what to pray for, the Spirit
prays for us in ways that cannot be put into words.

ROMANS 8:26 CEV

The Holy Spirit is the wind that blows through our world, breathing grace and life into everything that exists. He will breathe through you as well as you open yourself to Him. We need not worry about our own weakness or mistakes, for the Spirit will make up for them. His creative power will pray through us, work through us, and love through us.

Holy Spirit, thank You for interceding on my behalf,
for breathing grace and life into me. Even through
my weakness, thank You for Your power that
carries my very breath to God. Amen.

Day 237

PEACE IS A GUARD

Do not be anxious about anything, but in every situation,
by prayer and petition, with thanksgiving, present your requests to
God. And the peace of God, which transcends all understanding,
will guard your hearts and your minds in Christ Jesus.

PHILIPPIANS 4:6–7 NIV

Anxious thoughts and worry will try to attack us on a regular basis. Fear can so easily creep into our thinking and rob us of joy, the very treasure we hold because we know Christ.

Thankfully, we have been given the key to protecting our minds and hearts—prayer. In coming to God with our petitions and in giving thanks to Him for all He has already done for us, we receive His peace. Beyond our ability to understand or explain, a heaven-sent peace will abide with us.

What a beautiful picture: the Soldier of peace standing at the door of our hearts and minds, guarding the treasure of fellowship with Christ. It is ours for the asking when we go to our Father with all our requests.

Father, cause me to remember that Your peace is available
to guard me night and day. Help me to bring everything to
You in prayer, trusting in Your faithful provision. Amen.

Day 238
ETERNAL JOY!

*And the ransomed of the LORD shall return, and come to
Zion with songs and everlasting joy upon their heads: they shall
obtain joy and gladness, and sorrow and sighing shall flee away.*

ISAIAH 35:10 KJV

Have you ever pondered eternity? Forever and ever and ever. . . ?
Our finite minds can't grasp the concept, and yet one thing we
understand from scripture—we will enter eternity in a state of
everlasting joy and gladness. No more tears! No sorrow! An eternal
joy fest awaits us! Now that's something to celebrate!

*When life becomes difficult, help me to keep things in
perspective, Father. The hardships I face in the day-to-day
are but blips in time compared to the eternal joy I will
experience in heaven. Thank You for joy that lasts forever. Amen.*

Day 239

LIVING THE "WHAT IF" BLUES

*And we know that in all things God works for the good of those
who love him, who have been called according to his purpose.*

ROMANS 8:28 NIV

All of life's "not knowing" can prompt a lot of what-ifs. Pray for
wisdom and guidance, knowing that God will give them to you
freely and lovingly. But if you still take a wrong turn, embrace
His promise that He will work all things for good for those who
love Him. Hard to imagine, but the Lord really does mean "all
things." Praying and embracing His promises will go a long way in
keeping you on the right road, as well as easing those what-if blues.

*God, I'm so grateful You can turn evil
into good and sorrow into joy. Amen.*

Day 240
AN ATTITUDE

*GOD proves to be good to the man who passionately
waits, to the woman who diligently seeks. It's a good
thing to quietly hope, quietly hope for help from GOD.*
LAMENTATIONS 3:25–26 MSG

Hope is an attitude, not an emotion. It means putting our whole
hearts into relying on God. It means keeping our eyes focused on
Him no matter what, waiting for Him to reveal Himself in our
lives. God never disappoints those who passionately wait for His
help, who diligently seek His grace.

*God, help me to passionately wait and diligently
seek. Help me not to be frantic but to quietly hope
for the help that is sure to come from You. Amen.*

Day 241

SOUL CRAVINGS

As the deer pants for streams of water, so my soul pants
for you, my God. My soul thirsts for God, for the living
God. When can I go and meet with God?
PSALM 42:1–2 NIV

Our hearts have some indefinable yearnings. We look for fulfill-
ment from people, titles, achievement, chocolate. We may attempt
to squelch the longings with distractions of busyness, fashion, an
extra drink, motherhood, or even church work. But the longing
is a thirst for intimate connection with our God. Our souls pant
for Him! He alone quenches our needs.

The Spirit knows our subtle moods, our hearts' aches, and our
soul cravings. We must turn to Him in transparent prayer, mulling
the Word over in our minds, allowing it to penetrate the hidden
recesses of our souls.

God, You are the headwaters of life for me. Reveal the substitutes
I look to for fulfillment. Help me to drink deeply from Your Word
and Your abiding Spirit, that I might be complete in You. Amen.

Day 242

PRESSED DOWN, RUNNING OVER

*Give, and it shall be given unto you; good
measure, pressed down, and shaken together,
and running over, shall men give into your bosom.*
LUKE 6:38 KJV

"Give, and it shall be given unto you." Likely, if you've been walking
with the Lord for any length of time, you've heard this dozens of
times. Do we give so that we can get? No, we give out of a grate-
ful heart, and the Lord—in His generosity—meets our needs.
Today, pause and thank Him for the many gifts He has given you.
Do you feel the joy running over?

*Lord, help me to always give from a grateful heart and never because
I plan to get something in return. You have given me abundant
blessings, Father. Thank You for always meeting my needs. Amen.*

Day 243

THE WORRIER'S PSALM

Do not fret.
PSALM 37:1 NIV

Instead of fretting, delight in the Lord, and He will give you all your heart's desires. Especially if one of those desires is to be free from fretting. And even if you've prayed, breathed, and tried to relax and the worries still come, like houseflies that just refuse to find their way back out the screen, then don't fret about fretting. Trust. Commit. Be still. Wait. Refrain. Turn. Give generously. Lend freely. Do good. Hope. Consider. Observe. Seek peace. Just don't fret.

Dear God, You know our hearts and also the worries
that prey on our minds. Please help us to stay busy
doing good and to grow in trust and patience. Please help
us to let go of control we never had to start with. Amen.

Day 244

GRACE IN RETURN

*"Then those 'sheep' are going to say, 'Master, what are you
talking about? When did we ever see you hungry and feed you,
thirsty and give you a drink? . . .' Then the King will say, 'I'm
telling the solemn truth: Whenever you did one of these things to
someone overlooked or ignored, that was me—you did it to me.'"*

MATTHEW 25:37–40 MSG

If Christ were sitting on our doorstep, lonely and tired and hungry,
what would we do? We like to think we would throw the door wide
open and welcome Him into our home. But the truth is we're given
the opportunity to offer our hospitality to Jesus each time we're
faced with a person in need. His grace reaches out to us through
those who feel misunderstood and overlooked, and He wants us
to offer that same grace back in return.

*Jesus, open my eyes to the hungry and thirsty people all
around me. Whether their hunger is spiritual or physical
or both—help me to give them Your grace. Amen.*

Day 245

PRAYER REVEALS OUR DEPENDENCE

Then Jesus went with his disciples to a place called Gethsemane,
and he said to them, "Sit here while I go over there and pray."
MATTHEW 26:36 NIV

Jesus was humble. He conceded that He needed help. He admitted His human weakness. He acknowledged His struggle in the garden of Gethsemane. Confiding in His disciples, He revealed His anguish and pain. Then He turned to His heavenly Father. Jesus knew He needed God's help to endure the cross. Prayer revealed Jesus' utter dependence on God.

How much do you really need God? Your prayer life reveals your answer. If an independent attitude has crept into it, prayer may seem a ritualistic exercise. But if you realize your weakness and acknowledge your need, then prayer will become vital to your existence. It will become your sustenance and nourishment—your lifeline. Prayer reveals your dependence upon God. How much do you need Him?

Dear Lord, I truly need You. May my prayer life
demonstrate my dependence upon You. Amen.

Day 246

A SACRIFICE OF PRAISE

Is any among you afflicted? let him pray.
Is any merry? let him sing psalms.
JAMES 5:13 KJV

It's tough to praise when you're not feeling well, isn't it? But that's exactly what God calls us to do. If you're struggling today, reach way down deep. . . . Out of your pain, your weakness, offer God a sacrifice of praise. Spend serious time in prayer. Lift up a song of joy—even if it's a weak song! You'll be surprised how He energizes you with His great joy!

I'm struggling today, God. But that's no surprise to You,
is it? You know just how I feel. Please energize my
sluggish spirit. I want to sing praises to You! Amen.

Day 247

PLANTING

I planted the seed, Apollos watered it,
but God has been making it grow.
1 CORINTHIANS 3:6 NIV

Have you ever hesitated to engage in a spiritual discussion with a person because you didn't know how he would take it or you felt like you didn't have the time required to build a relationship with him? Of course, in an ideal world we'd have time to sit and chat with everyone for days, and the coffee would be free. But the fact that our world isn't ideal should not prevent us from planting a seed. You just never know what might happen to it. And that makes for some exciting gardening.

Dear God, thank You for allowing me to work for
Your kingdom. Help me to plant more seeds. Amen.

Day 248

ALL OF YOU

*"Love the Lord God with all your passion
and prayer and intelligence and energy."*
MARK 12:30 MSG

God wants all of you. He wants the spiritual parts, but He also wants
your emotions, your physical energy, and your brain's intelligence.
Offer them all to God as expressions of your love for Him. Let
His grace use every part of you!

*God, I sometimes forget that You want all of me. I dedicate
my emotions, my energy, and my intelligence to You.
Enable me to offer these as expressions of Your love. Amen.*

Day 249

FAITHFULNESS AND OBEDIENCE

"O Lord, God of Israel, there is no God like you in all of heaven and earth. You keep your covenant and show unfailing love to all who walk before you in wholehearted devotion."

2 Chronicles 6:14 nlt

After seven years of hard work, thousands of workmen, and unfathomable amounts of money, Solomon finally completed the temple. The priests carried the ark of the Lord's covenant into the inner room of the sanctuary, and suddenly, the presence of God appeared in the form of a cloud. The people were overjoyed, and Solomon led them in this prayer of thanksgiving and praise.

Sometimes, as God's people, we can be overwhelmed by the requests God makes of us. We may not be expected to build a temple, but God certainly asks us to obey Him in other ways. Thankfully, when we feel overcome with panic, we can rely on God's loving faithfulness to see us through our challenges. We simply must acknowledge God's power and eagerly obey His will.

Dear Lord, truly You are the one true God in all creation. Thank You for Your faithfulness and unfailing love. Teach me to eagerly obey Your will. Amen.

Day 250

JOYFUL IN GLORY

Let the saints be joyful in glory:
let them sing aloud upon their beds.
PSALM 149:5 KJV

When do you like to spend time alone with the Lord? In the morning, as the stillness of the day sweeps over you? At night, when you rest your head upon the pillow? Start your conversation with praise. Let your favorite worship song or hymn pour forth! Tell Him how blessed you are to be His child. This private praise time will strengthen you and will fill your heart with joy!

As I enter into this conversation with You, Father, I praise You.
Thank You for being Lord—and Leader—of my life. Amen.

Day 251

OUR GREAT CONTENDER

*Do not be far from me, Lord. Awake, and rise to my
defense! Contend for me, my God and Lord. Vindicate
me in your righteousness, LORD my God.*

PSALM 35:22–24 NIV

Our Lord God is the greatest warrior of all time. He is our
Guide, our Leader, our Defender, our Shield. He is all powerful,
all knowing, all mighty, and all good. Why would we ever hesitate
to call on Him? Why would we ever think that our own strength
could somehow be diminished by being supported by the Creator
of the universe? The next time you find yourself facing a battle,
don't wait. Don't try to do it on your own. Don't stand up by
yourself. Ask God to contend for you.

*Almighty God, please defend me from my
enemies and help me fight my battles. Amen.*

Day 252
SURRENDER

*"For whoever wants to save their life will lose it,
but whoever loses their life for me will save it."*

LUKE 9:24 NIV

Life is full of paradoxes. God seems to delight in turning our ideas inside out and backward. It doesn't seem to make sense, but the only way to possess our life is to surrender it absolutely into God's hands. As we let go of everything, God's grace gives everything back to us, transformed by His love.

*God, even when Your Word doesn't completely make sense,
help me to trust You implicitly. Give me the strength
to surrender every part of my life to You. Amen.*

Day 253

REMEMBER

*"I am the LORD your God, who brought you
out of Egypt, out of the land of slavery."*

EXODUS 20:2 NIV

Just before God gave the Israelites the Ten Commandments, He reminded them that He had brought them out of slavery in Egypt. It is easy for us to read this verse and wonder why the Israelites needed reminding. After years and years of harsh treatment and manual labor in Egypt, wouldn't they always be grateful to the Lord for delivering them from slavery?

Establish for yourself some reminders of God's blessings. Start a prayer journal where you can record your prayer requests and God's answers. Review the pages of your prayer journal when you face a hardship. Thank God for taking care of you in the past and ask Him to increase your faith. He wants you to trust that He will never leave you or forsake you.

Like the Israelites, we forget. God is faithful in *all ways* for *all days*. Remember that today.

*You are faithful, Father. You have freed me from the gates of hell
and given me an abundant life with the promise of eternity
with You. Grow my faith. Help me to remember. Amen.*

Day 254

EVERYDAY JOY

For in him we live, and move, and have our being.
ACTS 17:28 KJV

Every breath we breathe comes from God. Every step we take is a gift from our Creator. We can do nothing apart from Him. In the same sense, every joy, every sorrow. . .God goes through each one with us. His heart is for us. We can experience joy in our everyday lives, even when things aren't going our way. We simply have to remember that He is in control. We have our being. . .in Him!

Thank You for being in control of all things, God. I would rather have You by my side than anyone else in the world—through every up, down, and in between, You are there! Amen.

Day 255
ACT IN LOVE

Let all that you do be done in love.
1 CORINTHIANS 16:14 NRSV

Because love is not merely an emotion, it needs to become real through action. We grow in love as we act in love. Some days the emotion may overwhelm us; other days we may feel nothing at all. But if we express our love while making meals, driving the car, talking to our families, or cleaning the house, God's love will flow through us to the world around us—and we will see His grace at work.

Father, when I feel love, it's easy to show it. But the feelings are not always there. Help me to find ways to obediently express Your love through all my actions. Amen.

Day 256

SKEPTICS AND CYNICS

*For ever since the world was created, people have seen the
earth and sky. Through everything God made, they can clearly
see his invisible qualities—his eternal power and divine
nature. So they have no excuse for not knowing God.*

ROMANS 1:20 NLT

There are skeptics and cynics in our world. They love to question
the possibility of a divine Creator. They have seemingly sound
arguments based in logic and science. We can share testimonials,
blessings, and miracles from our personal lives and from scripture.
But these are often met with disbelief and tales of big bangs and
evolution.

In order for a skeptic to be changed to a seeker, Jesus must
grab his attention, often using His children to do that. Take time
to really consider the miraculous works of God that prove His
existence. Pray for wisdom and compelling words to lead cynics
to the throne.

*Father, help me to be a good witness of You and Your
miraculous wonders. Give me the words to convince even
the most hardened skeptic. Guide me to people, according
to Your will, so that I can make a difference. Amen.*

Day 257

THE NEARNESS OF YOU

Come near to God and he will come near to you.

JAMES 4:8 NIV

"Come near to God," we hear. And we think, *I can do that.* So we take our notebooks and buy the most inspirational Bibles complete with ribbon bookmarks and study notes, we create quiet-time nooks, we go sit under trees, we spiritually retreat and. . .find we are no closer. We don't feel closer to God; we feel tired.

So we follow the rest of James's instructions. We pray; we pour our hearts out and maybe even cry. We humbly admit our faults to God. Finally, James says, "*Now*, you've got it!" Because it was never about us making ourselves any better. We are messed-up people. Even our best efforts at doing better are going to get us nowhere in the end. Once we humbly admit that fact, God will lift us up. And *that's* how we get nearer, by realizing we can't do anything without Him.

My God, my Friend, my Lover, my Savior.
Humble me so You can lift me up. Amen.

Day 258
GO OUT WITH JOY

For ye shall go out with joy, and be led forth with peace:
the mountains and the hills shall break forth before you into
singing, and all the trees of the field shall clap their hands.

ISAIAH 55:12 KJV

God reveals Himself in a million different ways, but perhaps the most breathtaking is through nature. The next time you're in a mountainous spot, pause and listen. Can you hear the sound of God's eternal song? Does joy radiate through your being? Aren't you filled with wonder and peace? The Lord has, through the beauty of nature, given us a rare and glorious gift.

When I view the wonders of Your marvelous
creation, Lord, my heart fills with absolute joy! Amen.

Day 259
ABOVE ALL

Above all, love each other deeply,
because love covers over a multitude of sins.
1 PETER 4:8 NIV

How deep does your love go? Does it go as far as the distance that grows between two people? Does it cover little insults? Is it deep enough to silence words that should not be said? How deep does your love go? Does it go deep enough to trust? Can it cover over deceit? Does it go deep enough to swallow up betrayal? How deep does Jesus' love go?

Dear Jesus, help me to love as You love. Amen.

Day 260
CHRIST FOLLOWERS

"This is what the L<small>ORD</small> All-Powerful says: 'Do what is right and true. Be kind and merciful to each other.'"
Z<small>ECHARIAH</small> 7:9 NCV

As Christ's followers, we need to interact with others the way He did when He was on earth. That means we don't lie to each other and we don't use others. Instead, we practice kindness and mercy. We let God's grace speak through our mouths.

Lord All-Powerful, thank You for the blessing of relationships. Help me to do what is right and true, to be kind and merciful to others. Give me Your grace always. Speak through me. Amen.

Day 261

GRIEF-WORN

*Heal me, LORD, for my bones are in agony. My soul
is in deep anguish. How long, LORD, how long?*
PSALM 6:2–3 NIV

We struggle to find ways of expressing the bone-crushing weariness of grief. Sometimes it feels as though if we could just put it into words, maybe we could get past the sorrow.

But the psalmists have given us words: "I am worn out from my groaning. All night long I flood my bed with weeping and drench my couch with tears. My eyes grow weak with sorrow; they fail because of all my foes" (Psalm 6:6–7 NIV).

It is somehow comforting to know that souls from thousands of years ago can speak to us about the same feelings we have today. And that even though there is still pain and trouble and sorrow, there is also still our Lord God, who never changes: "The LORD has heard my weeping. The LORD has heard my cry for mercy; the LORD accepts my prayer" (verses 8–9 NIV).

*Dear God, hear me when I am sad and feel alone.
Show me that You are with me and that my
grief will not go on forever. Amen.*

Day 262
SECOND CHANCES

*For his anger lasts only a moment, but his
lasts a lifetime; weeping may stay for the night,
but rejoicing comes in the morning.*
PSALM 30:5 NIV

Don't you love second chances? New beginnings? If only we could go back and redo some of our past mistakes. . .what better choices we'd make the second time around. Life in Jesus is all about the rebirth experience—the opportunity to start over. Each day is a new day, in fact. And praise God! The sorrows and trials of yesterday are behind us. With each new morning, joy dawns!

*I am so glad You allow second chances, Father.
Thank You for each new morning that is
an opportunity to start over! Amen.*

Day 263
MORNING ORDERS

*"Have you ever given orders to the morning, or shown
the dawn its place, that it might take the earth by
the edges and shake the wicked out of it?"*

Job 38:12–13 NIV

God poses many rhetorical questions, all to show the might and wonder and mystery of the Almighty. In these words are some amazing ideas that really cause us to stop and consider who God is. And that is what we should do, especially when we face our worst trials. Stop and consider who God is. That no matter what happens, He will not leave us. And that He alone has the answers for us.

*Thank You, God, for providing glimpses
of You in Your Word. Amen.*

Day 264
RENEWAL

"Look, the winter is past, and the rains are over and gone."
SONG OF SOLOMON 2:11 NLT

Dreary times of cold and rain come to us all. Just as the earth needs those times to renew itself, so do we. As painful as those times are, grace works through them to make us into the people God has called us to be. But once those times are over, there's no need to continue to dwell on them. Go outside and enjoy the sunshine!

Father, it's easy to become discouraged during the long days of winter. But I know times of darkness are necessary to fully appreciate the joy of light. Help me to revel in Your sunlight. Amen.

Day 265

WHATEVER YOU ASK

"If you believe, you will receive whatever you ask for in prayer."
MATTHEW 21:22 NIV

The sky's the limit. That's essentially what Jesus told His disciples here. He said you can make a fig tree wither with a word or have a mountain throw itself into the sea. Magical things. The stuff of fairy tales.

Do you really believe? Will you receive whatever you ask?

Christians have nice answers for these questions when younger Christians ask them. We say that God works through our prayers. That if we are in God's will, we will ask for things that God wants to happen anyway. That if we don't have the right motives, we won't get what we ask.

And those things are all most likely true. But this illustration Jesus made here to His disciples has a different flavor to it, doesn't it? Here He seems to be pushing us to want something more. Something we think is impossible.

So what is your mountain?

God, help me truly believe. Amen.

Day 266

ENJOYING LIFE

May all who seek You rejoice and be glad in You;
and may those who love Your salvation say continually,
"May God be exalted!". . . You are my help and my savior.

PSALM 70:4–5 NASB

Sometimes we approach God robotically: "Lord, please do this for me. Lord, please do that." We're convinced we'll be happy, if only God grants our wishes, like a genie in a bottle. We're going about this backward! We should start by praising God. Thank Him for life, health, and the many answered prayers. Our joyous praise will remind us just how blessed we already are! Then—out of genuine relationship—we make our requests known.

Father God, my joy comes from You—and only
You. Without You I could never experience all of
the joys that life has to offer. Thank You! Amen.

Day 267

GLUE

He is before all things, and in him all things hold together.
COLOSSIANS 1:17 NIV

Have you ever felt like your life was falling apart? We need to know that there is someone who is holding us together, even when we feel like falling apart. Jesus has been with us since the beginning. He is "the beginning and the firstborn from among the dead" (Colossians 1:18 NIV). He can handle our struggles. And He can put us back together again, even if we let everything fall. There is always hope in Him.

*Dear Jesus, thank You for being a Friend I
can always count on. Help me remember to
trust You with all the details of my life. Amen.*

Day 268

QUIET GRACE

*Patient persistence pierces through indifference;
gentle speech breaks down rigid defenses.*
PROVERBS 25:15 MSG

When we're in the midst of an argument, we often become fixated on winning. We turn conflicts into power struggles, and we want to come out the victor. By sheer force, if necessary, we want to shape people to our will. But that is not the way God treats us. His grace is gentle and patient rather than loud and forceful. We need to follow His example and let His quiet grace speak through us in His timing rather than ours.

*Father, thank You for the gentleness of Your grace. Give me a
spirit of patient persistence. Instill my words with gentleness.
May I always value relationships over being right. Amen.*

Day 269

EVEN IF HE DOESN'T

"The God we serve is able to deliver us."
DANIEL 3:17 NIV

Shadrach, Meshach, and Abednego, followers of the one true God, refused to worship Nebuchadnezzar's idol. They knew what would happen to them for disobeying the king's orders, and they still refused, saying, "If we are thrown into the blazing furnace, the God we serve is able to deliver us from it, and he will deliver us from Your Majesty's hand" (Daniel 3:17 NIV). They definitely had confidence in their God.

But that wasn't all they said: "But even if he does not, we want you to know, Your Majesty, that we will not serve your gods or worship the image of gold you have set up" (verse 18 NIV). "Even if he does not."

Have you been praying hard for something to happen? Something you really care about? Are you able to pray those words too? *"God, even if You do not. . ."*

Help me, Lord, to believe even
when things don't go my way. Amen.

Day 270

THE KEY TO HAPPINESS

He who heeds the word wisely will find good,
and whoever trusts in the LORD, happy is he.
PROVERBS 16:20 NKJV

Want the key to true happiness? Try wisdom. When others around you are losing their heads, losing their cool, and losing sleep over their decisions, choose to react differently. Step up to the plate. Handle matters wisely. Wise choices always lead to joyous outcomes. And along the way, you will be setting an example for others around you to follow. So, c'mon. . .get happy! Get wisdom!

Father, thank You for the wisdom of Your Word,
which will always point me in the right direction
when I have a choice to make. Amen.

Day 271

HE WROTE THEM BOTH

God has made the one as well as the other.
ECCLESIASTES 7:14 NIV

We need to learn to see God's grace not just in what He does for us but in what He doesn't do. And we need to realize that the bit of the world we see is just one small piece of a very large story. So when we are standing in the middle of the book and the chapter is a sad and dreary one, we need to remember at least these two things: First, there are many pages to come; and second, it is by God's grace we are living this story, good or bad as it may be.

*Dear Author of my life, help me to remember
to trust You to write my story. Amen.*

Day 272

CONSTANT GRACE

*For Jesus doesn't change—yesterday, today,
tomorrow, he's always totally himself.*
HEBREWS 13:8 MSG

As human beings, we live in the stream of time. Sometimes all the changes time brings terrify us; sometimes they fill us with joy and excitement. Either way, we can cling to the still point that lies in the middle of our changing world: Jesus Christ, who never changes. His constant grace leads us through all life's changes, and one day it will bring us to our home in heaven, beyond time, where we will be like Him.

Jesus, how grateful I am that You stay the same. Yesterday, today, and forever, I can count on You to remain firm and steadfast, no matter how much change life brings. Amen.

Day 273

THE GRASS IS ALWAYS GREENER

And the peace of God, which transcends all understanding,
will guard your hearts and your minds in Christ Jesus.
PHILIPPIANS 4:7 NIV

When staring at everyone else's journey, you're bound to stumble on the road. Many times other people's lives appear happier, richer, fuller, maybe even more sanctified by God. When envy settles in, you tend to lose your grateful heart. You lose your way. And Satan is right there escorting you off the path and into a journey you were never meant to take—a fearsome passage you were never meant to walk. One without joy, laughter, hope, or peace.

Comparisons can mean a slow death of the spirit. The moment you catch yourself with the-grass-is-always-greener mentality, know that it will only lead you astray. So stay prayerfully focused on God and His way for you. Then the peace that passes all understanding will not be a distant mirage, but authentic and yours.

God, help me to be content and at peace with myself
and the life You have given me. I am unique
and valuable in Your eyes. Amen.

Day 274
NOT WITHHOLDING

*Anything I wanted, I would take. I denied myself
no pleasure. I even found great pleasure in
hard work, a reward for all my labors.*
ECCLESIASTES 2:10 NLT

Work beckons. Deadlines loom. You're trying to balance your home life against your work life, and it's overwhelming. Take heart! It is possible to rejoice in your labors—to find pleasure in the day-to-day tasks. At work or at play. . .let the Lord cause a song of joy to rise up in your heart.

*Help me to slow down—every day—and enjoy the
moments as they come, Father God. May I not become
so busy that I miss out on life's simple pleasures. Amen.*

Day 275

FATHER GOD

You are the helper of the fatherless.
PSALM 10:14 NIV

Some of us were blessed with great fathers. These were men who enriched our lives as role models, trainers, encouragers, supporters, huggers, comforters, and friends. But if your father was never there for you or is now gone, run to your Father God and spend some time with Him. Let Him heal the places in you that are hurting; let Him give you the confidence that comes from the only One in the world who has loved you since before the day you were born—and will continue to love you forever.

Dear Father, hear and bless Your children. Amen.

Day 276

ONLY BY GRACE

*Accept one another, then, just as Christ
accepted you, in order to bring praise to God.*
ROMANS 15:7 NIV

It's easy to pick out others' faults. Sometimes you may even feel justified in doing so, as though God will approve of your righteousness as you point out others' sinfulness. Don't forget that Christ accepted you, with all your brokenness and faults. Only by grace were you made whole. Share that grace—that acceptance and unconditional love—with the people around you.

*Jesus, what a joy it is to know that You have accepted
me just as I am! You have made me whole. Help
me to pass that grace on to others. Amen.*

Day 277

ONE WORD CHANGES EVERYTHING

He was despised and rejected by mankind, a man of suffering, and familiar with pain. Like one from whom people hide their faces he was despised, and we held him in low esteem.

ISAIAH 53:3 NIV

Have you ever felt abandoned? Misplaced? Abused? Rejected? Forgotten? We have all felt those feelings from time to time. What can we do about them? Well, the world has plenty of answers. Mask the anguish with painkillers, addictions, false teachings under the guise of spiritual enlightenment, and myriad other bogus remedies. You name it; the world is selling it as an alternative.

What to do? Face the unhappy pangs of this life by holding the hand of the One who has known all these trials—the One who knows better than anyone on earth what it feels like to suffer, to be rejected, abused, and forgotten. So, how does one do that, exactly? With the one word that the enemy of our souls wants us to forget. One word that can change everything—can bring meaning and hope and make that misery and aloneness flee to hell where it belongs.

It's prayer.

Father, help me to turn to You alone for my comfort instead of to the world. Amen.

Day 278

SOUL COMFORT

*In the multitude of my anxieties
within me, Your comforts delight my soul.*
PSALM 94:19 NKJV

We don't know for sure who wrote Psalm 94, but we can be certain that the psalmist was annoyed and anxious when he wrote it. He cries out to God, asking Him to "pay back to the proud what they deserve" (verse 2 NIV). Then, he goes on with a list of accusations about the evil ones. . . . "In the multitude of my anxieties within me." Does that phrase describe you? When anxiety overwhelms us, we find relief in the words of Psalm 94:19. When we turn our anxious thoughts over to God, He brings contentment to our souls.

Dear God, on those days when frustration and anxiety overwhelm me, please come to me, comfort my soul, and remind me to praise You. Amen.

Day 279
TO GET THE PRIZE

*Everyone who competes in the
games goes into strict training.*
1 Corinthians 9:25 niv

We are in the race of life. Time is short, but the days are long. We
have a lot to do, and we never know when our life will come to
an end. All of us are running to the same finish line. It's impor-
tant that we run our races in a way that shows we are serious
about getting the prize—eternal life with Christ. We need to
show that we are running toward something worth sacrificing
for. And we need to be prepared for whatever falls in our paths—
including other runners.

*Dear God, please help me "run in such a way as to
get the prize" (1 Corinthians 9:24 niv). Amen.*

Day 280

FRESH HEARTS

"I will give you a new heart and
put a new spirit within you."
Ezekiel 36:26 nkjv

Life is full of irritations and hassles. Bills to pay, errands to run,
arguments to settle, and endless responsibilities all stress our
hearts until we feel old and worn. But God renews us. Day after
day, over and over, His grace comes to us, making our hearts fresh
and green and growing.

Lord, when I focus on earthly things, my heart is small.
Expand my heart and give me a heavenly perspective,
knowing that You will redeem and make all things new. Amen.

Day 281

THE RADIANCE OF HIS SPLENDOR

*In the year that King Uzziah died, I saw the Lord, high
and exalted, seated on a throne; and the train of his robe
filled the temple. Above him were seraphim, each with six
wings: With two wings they covered their faces, with two
they covered their feet, and with two they were flying.*

ISAIAH 6:1–2 NIV

The book of Isaiah tells us that the Lord is exalted, seated on a throne, and the train of His robe fills the temple. Isaiah also talks about the angels who attend Him and worship Him—that their wings cover their faces, surely because of the radiance of His splendor. How fearsome and humbling and magnificent that sight must be!

In fact, this holy scene in the heavens should remind us that one day every knee shall bow and every tongue confess that He is Lord. Why wait until that final day? Why not give praise to the One—the only One—who is worthy of our raised hearts and hands? The One who is truly incredible and awesome and glorious!

*Lord God, help me to comprehend Your magnitude
and glory. I want to be awestruck by You. Amen.*

Day 282

VISIBLE REMINDERS

*Let the morning bring me word of your
unfailing love, for I have put my trust in you.*
PSALM 143:8 NIV

We don't know if David was a morning person or a night owl, but he chose to start his day looking for visible reminders of God's unfailing love. It might have been easy to remember God's love for him if he had witnessed a glorious morning sunrise, but if the night had been stormy and he was dealing with spooked sheep in the midst of a downpour, God's unfailing love may have felt a little distant. Whether or not conditions were favorable for faith, David believed in God's unfailing love—even if he couldn't see it in the world around him.

*I awake in the morning, and You are there. You are with
me all day long and throughout the night. Thank You,
heavenly Father, for Your ever-present love. Amen.*

Day 283

SEWING UP BROKEN HEARTS

He heals the brokenhearted and binds up their wounds.
PSALM 147:3 NIV

A heart that does not feel cannot be broken. But it also cannot love. And a heart that loves deeply can be wounded deeply. But God is the great Healer. And He knows how to heal deeply. God searches our hearts and finds the holes. Then He carefully, over time, joins the pieces together—with new love, care, and understanding. A broken heart will never be the same as an innocent one. It is forever scarred. But with the scarring comes wisdom, and that wisdom can blossom into compassion for others who have been hurt as well.

Dear Healer, mend the holes in my heart so
I can offer my whole heart to You. Amen.

Day 284

SLEEP IN PEACE

*At day's end I'm ready for sound sleep, for you,
God, have put my life back together.*
PSALM 4:8 MSG

At the end of the day, let everything—good and bad together—drop into God's hands. You can sleep in peace, knowing that meanwhile God will continue to work, healing all that is broken in your life. Relax in His grace.

Father, thank You for the gift of rest—a time to put the busyness aside. When I wake, things make much more sense. Thank You for putting my life back together! Amen.

Day 285

VOLATILE LIQUID

*"Therefore I tell you, do not worry about your life, what
you will eat or drink; or about your body, what you will
wear. Is not life more than food, and the body more than
clothes? Look at the birds of the air; they do not sow or reap
or store away in barns, and yet your heavenly Father feeds
them. Are you not much more valuable than they?"*

MATTHEW 6:25–26 NIV

Women tend to be like vats of worry. We toss everything imaginable into that emotional, messy brew. You know what I mean—the many frets that we distill down when we choose to hand-wring through our days and toss and turn through our nights. Then we pour that volatile liquid into spray bottles, and we hose down our friends and family with it.

Jesus asks us if we can add a single hour to our life with worry. We cannot. Jesus also says that the birds are cared for and that we are much more valuable to Him than they are. So what are we to do?

We can pray.

It's real. It's powerful. And our friends and family will thank us!

*Father, remind me that You're in control. I place
my burdens and fears in Your capable hands. Amen.*

Day 286
GOD OF POSSIBLE

Jesus looked at them and said, "With man this is
impossible, but with God all things are possible."
MATTHEW 19:26 NIV

No one can be saved by their own efforts! Man's greatest efforts
pale in comparison to the requirements of a holy God. But grace,
freely offered by God and accepted by individuals, will admit us
to heaven. With God, all things *are* possible—especially enabling
forgiven sinners to live eternally. Realizing we can do nothing is
the key to gaining everything.

Dear Father, I appreciate Your grace—Your loving-kindness
that I don't deserve. There is nothing I have done to earn
it. Grace is Your gift to me, and I thank You. Amen.

Day 287

SHINE

"Those who are wise will shine like the brightness
of the heavens, and those who lead many to
righteousness, like the stars for ever and ever."
<small>DANIEL 12:3 NIV</small>

The next time you are feeling a little frumpy or gray, a little old and tarnished, thank God for the wisdom you have. Think about the best decisions you made in the past year. Then pick yourself up, put on something shiny (an aluminum-foil tiara? a bouquet of silverware?) and take your own photo. Print it out and write beneath it, "I Shine." Then put it somewhere to serve as a reminder that being wise can be beautiful too.

Dear Lord, thank You for allowing
me to shine with wisdom. Amen.

Day 288

TODAY—AND TOMORROW

*You are my strong shield, and I trust you completely. You have
helped me, and I will celebrate and thank you in song.*

PSALM 28:7 CEV

God proves Himself to us over and over again. And yet over and
over, we doubt His power. We need to learn from experience. The
God whose strength rescued us yesterday and the day before will
certainly rescue us again today. As we celebrate the grace we re-
ceived yesterday and the day before, we gain confidence and faith
for today and tomorrow.

*My Father, my strong Shield, You have proved
Yourself to me over and over again. Remind me of Your
goodness. I praise You and celebrate Your faithfulness. Amen.*

Day 289
VOICE OF HEAVEN

*Jesus answered, "I am the way and the truth and the life.
No one comes to the Father except through me."*

JOHN 14:6 NIV

The world never seems to be in sync with what God wants for us, dreams for us. We get the idea that what the fallen earth has to offer is more fascinating and glorious and irresistible. Yet how can that be, when people fail us and everything that *can* fall apart *does* fall apart? When even the kings and queens of this earth are destined to the same lonely and hopeless end without divine assistance?

There are no answers in this earthy dust, only in the voice of heaven. We should look up to our hope—for it lies in Christ and Christ alone. He is life, not death. He is the most fascinating and glorious and irresistible hope there ever was or ever will be. This could be our heart praise as dawn arrives and as the sun sets.

*God, You are the answer to the riddles and the problems
of life. You are the salve for my sin-sick soul. Amen.*

Day 290

PLANTED DEEP

Fix these words of mine in your hearts and minds; tie them
as symbols on your hands and bind them on your foreheads.

DEUTERONOMY 11:18 NIV

Memorizing Bible verses isn't a fashionable trend in today's world, but learning key verses plants the Word of God deeply in our hearts. We draw strength and nourishment in dark times from remembering what God told us in the Bible. In times of crisis, we recall God's promises of hope and comfort. In our everyday moments, repeating well-known verses reminds us that God is always with us—whether it feels like it or not.

What an awesome gift You have given me, God—the
Bible! I will fix Your words in my mind and heart
and carry them with me wherever I go. Amen.

Day 291

WOMEN WHO LOVED WELL

Charm is deceptive, and beauty is fleeting.
PROVERBS 31:30 NIV

In the end, it will matter to Jesus, of course, that we knew Him as our Friend and Savior, but it will also matter that while we walked this earthly life, we loved well. That we saw a need and met it. That we smiled when we wanted to frown. That we were handier with a cup of cool water than a witty comeback. That we chased after a lost soul faster than we chased after a good time. That we loved other people as ourselves. Those things will matter a great deal, and with the power of the Holy Spirit, all those things are within our grasp. They are also ours to give away. Fully, freely—and daily.

Heavenly Father, help me to focus on cultivating those qualities and virtues that are lasting and will make an eternal impact for Your kingdom. Amen.

Day 292
WONDERFUL!

Commit your actions to the LORD,
and your plans will succeed.
PROVERBS 16:3 NLT

Just because we want something to happen doesn't mean it will, no matter how hard we pray. We've all found that out (often to our sorrow!). But when we truly commit everything we do to God, praying only for His grace to be given free rein in our lives, then we will be surprised by what comes about. It may not be what we imagined—but it will be wonderful!

Father, Your Word tells me that Your ways are not my ways.
I pray that I would graciously commit all my plans to You,
armed with the promise that You will help them succeed. Amen.

Day 293

ALL OF THE ABOVE

For the LORD gives wisdom; from his mouth
come knowledge and understanding.
PROVERBS 2:6 NIV

It's so easy to fall into the trap of thinking that if we simply pray about an issue, God will give us the answer—and in fairly short order. . .because God knows we need all the answers we need when we need them, and not a moment later. Right?

It seems that often when we want an answer, the only thing that will do is the answer we want. Nothing less. Yet God, our generous Father, has something better in mind. We want a solution; He wants to give us the formula. We want a simple yes or no; He wants to give us time to see if we even asked the right question. We want *A, B, C,* or *D;* He wants to give us all of the above.

Thank You, Lord, that Your ways are higher and wiser and
better than mine. Help me to be patient when I lack wisdom
and to seek Your knowledge and understanding. Amen.

Day 294
KEEP SMILING

"When they were discouraged, I smiled and that
encouraged them and lightened their spirits."
JOB 29:24 TLB

Our most authentic forms of communication occur without a
word. Rather, they flow from an understanding smile, a compas-
sionate touch, a loving gesture, a gentle presence, or an unspoken
prayer. God used Job, an ordinary man with an extraordinary
amount of love and wisdom—a man whose only adornment was
righteous living and a warm smile. And He wants to use us too.
So keep smiling. Someone may just need it.

Remind me, Jesus, to bless others through my actions. A warm
smile, a simple act of kindness, a loving touch might be just
what someone needs today. Remind me, please. Amen.

Day 295

THE TREES THAT
CATCH THE STORM

*Brothers and sisters, I could not address you as people who
live by the Spirit but as people who are still worldly—mere
infants in Christ. I gave you milk, not solid food, for you
were not yet ready for it. Indeed, you are still not ready.*
1 CORINTHIANS 3:1–2 NIV

Think of the healthiest trees that shoot up from the forest floor. . .
they stretch toward the sun and spread their branches wide. But
when the storms of life blow through, many times it's those towering
oaks that will catch the brunt of the wind. The last thing the enemy
of your soul wants is for you to grow in Christ and His wisdom.
So expect storms, and be watchful and ready. But remember too
that we can stand strong like the oak trees. We can know peace in
the midst of the gale. For Christ is the strength in our branches
and the light that gives us life!

*Jesus, help me to grow strong in the rich, nourishing soil of
Your love and grace. Make me a warrior for Your cause. Amen.*

Day 296

ON TRUTH'S SIDE

We're rooting for the truth to win out in you.
We couldn't possibly do otherwise.
2 CORINTHIANS 13:8 MSG

As we look at the world around us, we can see that people often prefer falsehoods to truth. They choose to live in a world that soothes their anxiety, rather than face life's reality. We cannot force people to acknowledge what they don't want to face, but we can do all we can to encourage them and build them up. We can cheer for the truth, trusting that God's grace is always on truth's side.

Father, Author of truth, open my eyes to the
truth of Your Word. Help me not to be swayed by
falsehood but instead to cling to Your truth. Amen.

Day 297

COMMANDING PRESENCE

*Trouble and distress have come upon me, but
your commands give me delight.*
PSALM 119:143 NIV

The word *commands* is not generally seen in a positive light.

Yet God commands. When people come into His commanding presence in prayer, they do find comfort. Why? Because when the foundations of your life are shaken, you want to hold on to something that is real, that is true, that will not and cannot be moved. The law of the Lord is that. Moreover, His law is *good*.

The more you meditate on His Word, the more you'll be convinced of this. Use the laws of God in your prayer time, and you will be forced to think about others, to consider what it means to really live in community and to put others before yourself. In that process, the sorrow and trouble that is weighing you down will not disappear but will be put in proper perspective—and thus, become a little bit of a lighter load.

*Lord, thank You for the comfort
You bring us in Your law. Amen.*

Day 298

JOYFUL SERVICE

*Wherefore I put thee in remembrance that thou
stir up the gift of God, which is in thee.*

2 TIMOTHY 1:6 KJV

This passage is a reminder to every believer. It demonstrates that our God-given gifts remain strong only through active use and fostering. Gifts left unattended or unused become stagnant and, like an unattended fire, die. Just as wood or coal fuels a fire, faith, prayer, and obedience are the fresh fuels of God's grace that keep our fires burning. But this takes action on our part. Are you using the gifts God has given you? Can He entrust you with more? Perhaps today is the day to gather the spiritual tinder necessary to stoke the fire of God within.

*God, You have given me special talents and inspiring gifts.
I pray, open my eyes to sharing those gifts. Through faith
and obedience I will joyfully use them to serve You. Amen.*

Day 299
WHAT TO DO WITH FREE WILL

*"If you do what is right, will you not be accepted? But if
you do not do what is right, sin is crouching at your door;
it desires to have you, but you must rule over it."*

Genesis 4:7 niv

Every single thing we do every minute of the day involves a choice,
and everything has a ripple effect. Everything has consequences.
What we eat for breakfast. What books we read, what programs we
watch on TV. Where we go, what we spend our time and money
on. Sin is always crouching at our door, but with the help of the
Holy Spirit, we can ask it to leave. What will your choices be today?

*Holy Spirit, guide me in my decisions. Help me
to be wise, clearheaded, and motivated by a
selfless love for You and others. Amen.*

Day 300
MOST IMPORTANT

*Tune your ears to the world of Wisdom; set
your heart on a life of Understanding.*
PROVERBS 2:3 MSG

What do you listen to most? Do you hear the world's voice telling you to buy, buy, buy, to dress and look a certain way, to focus on things that won't last? Or have you tuned your ears to hear the quiet voice of God's wisdom? You can tell the answer to that question by your response to yet another question: What is most important to you? Things? Or the intangible grace of true understanding?

*Lord, You are wisdom. Tune my heart to Your wise voice.
Make Your priorities my priorities, and fill my heart
with Your wisdom and Your understanding. Amen.*

Day 301

NOT YOUR BATTLE

*"All those gathered here will know that it is not by
sword or spear that the LORD saves; for the battle is
the LORD's, and he will give all of you into our hands."*

1 SAMUEL 17:47 NIV

David was in an ugly fight. Goliath was not exactly a humble opponent. He was big and loud and mean and scary. The Israelites were not showing themselves to be especially brave at the time. So David, the shepherd, stepped into the middle of this mess armed not with swords and catapults and spears, and not even with a sling and a stone. No, David was armed with the strength and power and might of the living God.

You are too. Perhaps you haven't seen God rescue you from the paw of a lion or bear, as David had. Yet you can be confident that God is more than able to get you through whatever challenge you are facing. Spend some time with Him. Ask Him to help you. Place your battle in His capable hands.

Dear Lord, please let me lean on You. Amen.

Day 302

ENDLESS SUPPLY

We love because he first loved us.

1 JOHN 4:19 NIV

The power of God's love within us fuels our love when human love is running on empty. He plants His love within our hearts so we can share Him with others. We draw from His endless supply. Love starts with God. God continues to provide His love to nourish us. God surrounds us with His love. We live in hope and draw from His strength, all because He first loved us.

Oh God, the human love I know on earth cannot compare with Your love. When I feel empty, Your love fills me up. Your love is perfect. It never fails. Amen.

Day 303

ALL THE LONELY PEOPLE

Be devoted to one another in love.
Honor one another above yourselves.
ROMANS 12:10 NIV

As Christians, let's keep an eye out for those lonely souls, the people who need a smile and a helping hand. Those who need a cup of cool water and a listening ear—who need a friend. Let us open our hearts and homes to them. As the book of Romans reminds us, "Be devoted to one another in love. Honor one another above yourselves." This is God's cure for all the lonely people. Amazingly enough, when we reach out to lessen someone else's lonesomeness, perhaps we will ease our own.

Father, give me the desire to live my life for You and
for everyone around me. Deepen and enrich my
relationships with family and friends. Amen.

Day 304

NEVER BOUGHT

They trust in their riches and brag about all of their
wealth. You cannot buy back your life or pay off God!
Psalm 49:6–7 cev

We humans are easily confused about what real wealth is. We think that money can make us strong. We assume that physical possessions will enhance our importance and dignity in others' eyes. But life is not for sale. And grace can never be bought.

Heavenly Father, I am tempted to trust in worldly riches, but
I know they will never truly satisfy. Help me to long for true
wealth, which lies in the promise of eternal life with You. Amen.

Day 305

WATCHING FROM THE REEDS

*Then she placed the child in it and put it among
the reeds along the bank of the Nile.*

EXODUS 2:3 NIV

There is very little emotion captured in the story of baby Moses. A woman has a baby. She can't hide him from the cruel government, which legislated his death, so she puts him in a basket in the river. No tears. No sound. The end.

It wasn't the end, thankfully, for baby Moses. It's hard to imagine that was the end for his mother either. Even after her daughter followed the baby boy, watching him be rescued by royalty; even after she finished nursing her son and gave him back to be raised by his adoptive family; even after the boy had grown up and fled the land—it seems likely that it wasn't the end of the story for Moses' mother.

How many mothers are out there who have watched from the reeds and prayed? Say a prayer today for those mothers watching from the reeds.

*Dear Lord, thank You for the gift of life. Please bless all those mothers
who have made sacrifices so their babies could survive. Amen.*

Day 306
ENGRAVED

"See, I have engraved you on the palms of my hands."
ISAIAH 49:16 NIV

In the middle of tumultuous times, it's tempting to proclaim that God has forgotten us. Both Israel and Judah struggled with the idea that God had abandoned them. But God took steps to contradict this notion. In an image that prefigures Jesus' crucifixion, God boldly proclaimed that His children were engraved on the palms of His hands. The nail-scarred hands that His Son would endure bear the engraved names of all of us who call upon Him as Savior and Lord. God does not forget us in the midst of our troubles! It is His nail-scarred hand that reaches down and holds our own.

Jesus, the scars on Your hands are because of me—a testament to my salvation. My name is engraved on Your hand as a child of God. Oh, thank You, dear Jesus! Amen.

Day 307

TURNING BONDAGE INTO BALANCE

It is for freedom that Christ has set us free.
Stand firm, then, and do not let yourselves
be burdened again by a yoke of slavery.
GALATIANS 5:1 NIV

The Lord wants us to have a sound mind, which means finding balance in life. How can we be warm, giving, creative, fun, and a light to the world if we are frozen solid in an unmovable block of perfectionism? Let Jesus melt the block of bondage that says, "Never good enough," and let us be able to shout the words "It is good, and it is finished. Praise God!"

Lord, help me not to be a slave to perfectionism,
but in all things, let me find balance and joy. Amen.

Day 308
PERFECTION

I don't mean to say that I have already achieved these things
or that I have already reached perfection. But I press on to
possess that perfection for which Christ Jesus first possessed me.
PHILIPPIANS 3:12 NLT

We are called to be perfect. Nothing else is good enough for God's people. That doesn't mean we have an inflated sense of our own worth. And it doesn't mean we beat ourselves up when we fall short of perfection. We know that in our own strength we can never hope to achieve perfection—but with God's grace, anything is possible.

Jesus, when I am weary, give me the strength to keep
pressing forward toward perfection. I want, more than
anything, to be like You. Fill me with Your grace. Amen.

Day 309

HELPER OF THE FATHERLESS

But you, God, see the trouble of the afflicted; you consider
their grief and take it in hand. The victims commit
themselves to you; you are the helper of the fatherless.

PSALM 10:14 NIV

Losing a parent shakes a person's foundations. Both sons and daughters feel this loss keenly, though perhaps somewhat differently. For sons, it is the loss of a role model, a strength giver, a provider, a teacher. For many daughters, losing a father means all of that; but it also means losing the first and perhaps the only man in the world who would truly love them no matter what. The one man who would always look at them and say with absolute honesty, "You are beautiful."

God sees your troubles, and He knows your pain. When you come to Him in prayer, He cradles you in the palm of His hand because He is that big. Big enough to take on your sorrow. Big enough to lift us all. Yet close enough and gentle enough to wipe your tears and whisper, *"You are beautiful."*

Father God, thank You for never
leaving me. Please hold on tight. Amen.

Day 310

EVERY MOMENT...

He will not let your foot slip—he who
watches over you will not slumber.

PSALM 121:3 NIV

The psalms tell us that God does *not* sleep. He watches over us, never once averting His eyes even for a few quick moments of rest. God guards our every moment. The Lord stays up all night, looking after us as we sleep. He patiently keeps His eyes on us even when we roam. He constantly comforts when fear or illness makes us toss and turn. Like a caring parent who tiptoes into a sleeping child's room, God surrounds us even when we don't realize it. We can sleep because God never slumbers.

Oh God, how grateful I am that You never sleep. When
weariness overtakes me, You guard me like a mother who
watches over her child. I love You, Father! Amen.

Day 311

THE TIME IS NOW

But God demonstrates his own love for us in this:
While we were still sinners, Christ died for us.
ROMANS 5:8 NIV

In the book of Mark, Jesus said, "The time has come.... The kingdom of God has come near. Repent and believe the good news!" (1:15 NIV). Have you embraced this good news? The kingdom of God has come near to you. Why are you waiting? The time is now. Ask the Lord for forgiveness and be free. Believe in Him as Lord and be made right with God. Accept His grace and live with the Lord for all time. Oh yes, what a joy—to know love the way it was meant to be!

Thank You, Lord Jesus, that even while I was deep in
my sin, You gave up Your life so that I might truly live.
What a sacrifice. What a Savior! Thank You for Your
unfathomable mercy, Your immeasurable love. Amen.

Day 312

A SPECIAL KIND OF GRACE

Oh, how blessed are you parents, with your quivers
full of children! Your enemies don't stand a chance
against you; you'll sweep them right off your doorstep.

PSALM 127:5 MSG

What are your worst enemies? Despair? Self-doubt? Selfishness?
We all face enemies like these. But God's grace comes to us in
a special way through children. As we love them, we find hope;
we focus outward and forget about ourselves. And somehow
those funny little people manage to sweep our enemies right off
the doorsteps of our hearts!

Heavenly Father, thank You for the blessing of little children.
Thank You for the way they bring hope and simplicity to my life,
putting even my darkest circumstances in perspective. Amen.

Day 313

TRANSFORMING

*And we all, who with unveiled faces contemplate the
Lord's glory, are being transformed into his image with
ever-increasing glory, which comes from the Lord, who is the Spirit.*
2 Corinthians 3:18 niv

Thanks be to God, "where the Spirit of the Lord is, there is free-dom" (2 Corinthians 3:17 niv). No one has to hide from the Lord. No one has to worry about the exterior image. No one has to feel alone.

If you have been running away from God for a while, or just neglecting your prayer life, it's time to turn and face Him. He does not expect you to be perfect. He expects that you will need transforming. He is happy to perform that work. He wants to shape you into the best human being you can be. Come and kneel before Him; don't hide your face. He can see through any veil you might try to wear, anyway. Come and stand before His image and ask Him to transform you.

*Dear God, I'm not happy with who I am. Please
mold me into the person You want me to be. Amen.*

Day 314

RENEWAL OF ALL THINGS

Peter answered him, "We have left everything to follow you!
What then will there be for us?" Jesus said to them, "Truly
I tell you, at the renewal of all things, when the Son of Man
sits on his glorious throne, you who have followed me will also
sit on twelve thrones, judging the twelve tribes of Israel."

MATTHEW 19:27–28 NIV

None of us will just occupy space in heaven. Our God is always productive. And this job to which Jesus refers, that of judging the twelve tribes of Israel, will be given to the disciples. Have you ever speculated as to what you might do in heaven? Well, don't worry; it's not going to be anything like what you've done on earth. Your "boss," after all, will be perfect. And the tasks you perform will be custom-tailored to you. "Job satisfaction" will finally fit into our vernacular.

Lord, I can't even imagine what You have in
store for me in heaven. Please keep me faithful to
complete the duties You've called me to on earth. Amen.

Day 315

DOORS OF OPPORTUNITIES

*And so find favor and high esteem
in the sight of God and man.*
PROVERBS 3:4 NKJV

God wants you to experience every favor and rich blessing He's prepared. By faith, expect blessing to meet you at every turn. Imagine what your future holds when you become determined to step out to greet it according to God's design. Remain alert and attentive to what God wants to add to your life. Expect the goodness He has planned for you—doors of opportunities are opening for you today!

*Lord, thank You for setting favor and blessing in my path, and
help me to expect it wherever I go and in whatever I do. Amen.*

Day 316

GRACE FOR EACH DAY

May the Lord direct your hearts into God's
love and Christ's perseverance.
2 Thessalonians 3:5 niv

Allow God to lead you each day. His grace will lead you deeper and deeper into the love of God—a love that heals your wounds and works through you to touch those around you. Just as Christ never gave up but let love lead Him all the way to the cross, so too God will direct you all the way, giving you the strength and the courage you need to face each challenge.

Lord, direct my heart into Your love and into the
perseverance of Christ. Lead me, by Your grace,
into a deeper love for You. Amen.

Day 317

HOW BEAUTIFUL IS THY NAME!

All flocks and herds, and the animals of the wild, the birds in the
sky, and the fish in the sea, all that swim the paths of the seas.
LORD, our Lord, how majestic is your name in all the earth!
PSALM 8:7–9 NIV

When we experience an alpine walk along a misty trail or take in
the moon's reflection on a still blue sea; when we hear the thun-
derous roar of a lion or the voice of the wind through swaying
palms. . .don't we feel a sweet ache in our hearts to be thankful—to
Someone?

God's creation is indeed full of beauty and wonder, and we
should take great pleasure in His handiwork. We should explore
His world. We should see with new eyes each morning.

As Christians we do not worship creation, but we instead
worship the One who is the Creator of such magnificence. A
thankful heart full of praise is a form of prayer. Shall we thank
Him and praise Him today?

Lord, our Lord, how majestic is Your name in all the earth!

Creator God, thank You for the beauty and wonder of Your
handiwork. Give me grateful eyes to see it every day. Amen.

Day 318

EVERYDAY BLESSINGS

But the eyes of the LORD are on those who fear him,
on those whose hope is in his unfailing love.

PSALM 33:18 NIV

The Lord of all creation is watching our every moment and wants to fill us with His joy. He often interrupts our lives with His blessings: butterflies dancing in sunbeams, dew-touched spiderwebs, cotton-candy clouds, and glorious crimson sunsets. The beauty of His creation reassures us of His unfailing love and fills us with hope. But it is up to us to take the time to notice.

May I always be aware of Your lovely creation, Father
God. Your artistry never fails to amaze me! Amen.

Day 319

TREMBLING WHILE TRUSTING

And straightway the father of the child cried out, and said
with tears, Lord, I believe; help thou mine unbelief.

MARK 9:24 KJV

When the Lord looks at us, what does He see? Do we trust Him enough to be vulnerable? Are we willing to obey even when we are afraid? Do we believe Him? Do not be afraid to follow Him, and do not let your trembling hold you back. Be willing to take a step of faith. If you are scared, God understands and is compassionate and merciful. Fear does not negate His love for you. Your faith will grow as you trust Him. Let's trust even while trembling.

Dear Lord, help my unbelief. Enable me to trust
You even though I may be trembling. Amen.

Day 320

RECIPROCAL

When we get together, I want to encourage you in your faith, but I also want to be encouraged by yours.

ROMANS 1:12 NLT

Encouragement is always reciprocal. When we encourage others, we are ourselves encouraged. In the world's economy, we pay a price in order to receive something we want; in other words, we give up something to get something. But in God's economy, we always get back what we give up. We are connected to each other, like parts of a body. Whatever good things we do for another are good for us as well.

God, thank You for the encouragement I find from my brothers and sisters in You. Help me to both share and receive the encouragement of Your love. Amen.

Day 321

THE BLUEPRINT

"And even the very hairs of your head are all numbered."
MATTHEW 10:30 NIV

We each are uniquely and wonderfully made. It is our loving Creator who holds that blueprint—which He considers precious—that has your name on it.

Imagine God so loving the world—loving us—that His "knowing" extends to the number of hairs on our heads. He knows every single thing about us. The kind of friends we enjoy. Our favorite ice cream, favorite pets, and favorite hobbies. The things that tickle our funny bones. The things that make us cry at the movies. Every secret we've hidden. Our deepest longings. Our worst nightmares. Yes, the Lord knows every nuance and detail about us. He loves us dearly.

Knowing these truths will help us to pray, since being loved and understood by the One to whom we are praying makes all the difference in the way we begin, "Dear Lord. . ."

Thank You for knowing and loving every single part of me. Help me to run to You when I feel misunderstood or forgotten. Amen.

Day 322
JOY: JESUS OCCUPYING YOU

May all who fear you find in me a cause for joy,
for I have put my hope in your word.
PSALM 119:74 NLT

Have you ever met someone you immediately knew was filled with joy—the kind of effervescent joy that bubbles up and overflows, covering everyone around her with warmth and love and acceptance? We love to be near people filled with Jesus joy. And even more, as Christians we want to be like them!

Lord, show me how to radiate Your joy in the presence of others. I want to be a light for You. Amen.

Day 323
GET REAL

The Lord says: "These people come near to me with their mouth and honor me with their lips, but their hearts are far from me. Their worship of me is based on merely human rules they have been taught."

ISAIAH 29:13 NIV

The world is full of hypocrites. To be honest, sometimes the church is too—hypocrites who profess to know and honor God, but when it comes right down to it, only go through the motions of religion. Their hearts are far from Him. Take the time to find out who God is, what He has done for you, and why He is worthy of your devotion. Following God is not about a bunch of man-made rules. He loves you; He sent His Son to die for you; and He longs to have a deep, personal relationship with you. Get real with God and get real with yourself!

Dear God, reveal Yourself to me. Show me who You are and show me how to live so that I honor You, not only with my lips, but with my heart as well. Amen.

Day 324

NO DIVISION

*In Christ's family there can be no division into Jew and non-Jew,
slave and free, male and female. Among us you are all equal.*
GALATIANS 3:28 MSG

Grace is a gift that none of us deserve—and by grace Jesus has
removed all barriers between God and ourselves. God asks that
as members of His family we also knock down all the walls we've
built between ourselves and others. Not just the obvious ones, but
also the ones that may hide in our blind spots. In Christ, there is
no liberal or conservative, no educated or uneducated, no division
whatsoever.

*God, Your Son broke down all the walls. I am so grateful
that there is no longer any division among Your children.
Thank You for making us all equal in Your sight. Amen.*

Day 325

BETTER TO ENDURE

"He cuts off every branch in me that bears no fruit,
while every branch that does bear fruit he prunes
so that it will be even more fruitful."

JOHN 15:2 NIV

How many times have we met children who haven't been disciplined by their parents, who've been given whatever they wanted, whenever they wanted, without any sensitivity to what they really needed? Not a pretty sight. Later, they end up being such miserable adults that they may even miss out on what they were destined to be.

The Lord wants the best for each of us—and the best sometimes requires that uncomfortable d-word. *Discipline.* But wouldn't it be better to endure God's occasional pruning than the devil's persuasions and praise? The Lord wants more for us than we can even imagine for ourselves.

Thank God today for His corrections for they are full of mercy and love.

They are beautiful.

Dear Lord, thank You for always desiring what is best
for me, even if it sometimes requires painful discipline.
Help me to trust Your sovereignty and love. Amen.

Day 326
A NEW DAY

GOD, treat us kindly. You're our only hope. First thing in the
morning, be there for us! When things go bad, help us out!
ISAIAH 33:2 MSG

Every day is a new day, a new beginning, a new chance to enjoy
our lives—because each day is a new day with God. We can focus
on the things that matter most: worshipping Him, listening to
Him, and being in His presence. No matter what happened the
day before, we have a fresh start to enjoy a deeper relationship
with Him. A fresh canvas, every twenty-four hours.

Before I get out of bed in the morning, let me say these words
and mean them: "This is the day that the LORD has made;
let us rejoice and be glad in it" (Psalm 118:24 ESV). Amen.

Day 327
I THINK I CAN

"Do not be afraid; only believe."
MARK 5:36 NKJV

Take a trip through the Bible and you'll see that those God asked to do the impossible were ordinary people of their day, yet they demonstrated that they believed God saw something in them that they didn't see. He took ordinary men and women and used them to do extraordinary things. When you believe you can do something, your faith goes to work. You rise to the challenge, which enables you to go further than before, to do more than you thought possible. Consider trying something new—if you think you can, you can!

God, I want to have high expectations. I want to do more than most think I can do. Help me to reach higher and do more as You lead me. Amen.

Day 328

LETTING GO

A peaceful heart leads to a healthy body;
jealousy is like cancer in the bones.
PROVERBS 14:30 NLT

Some emotions are meant to be nourished, and others need to be quickly dropped into God's hands. Learn to cultivate and seek out that which brings peace to your heart. And practice letting go of your negative feelings as quickly as you can, releasing them to God. If you cling to these dark feelings, they will reproduce like a cancer, blocking the healthy flow of grace into your life.

Oh God, search me and know my heart. Expose any
negative feelings in me. Help me to leave them at the cross.
Cleanse me and fill my heart with Your peace. Amen.

Day 329

SPA DAY FOR THE SOUL

One of those days Jesus went out to a mountainside
to pray, and spent the night praying to God.
LUKE 6:12 NIV

What about having a spa day for the soul? Talk about rejuvenating. We would come away with a new outlook, a smile on our lips, and a song in our hearts. Our spirits might even feel ten years younger.

When Jesus walked among us, He showed us how important prayer was. It says in God's Word that Christ went out to the mountainside to pray and spent the night praying to God. He knew how powerful and vital prayer was and how He needed it to stay the course.

So are you ready to schedule a spa day for your soul? A day of prayer and communion with your Lord? Or even an hour on Sunday? The luxury of this refreshment is gratis, and its beautification will be a lift to the body and spirit.

Lord, help me to remember to regularly refresh
my spirit through prayer. My soul needs You
as much as my body needs oxygen. Amen.

Day 330

OWNING YOUR FAITH

"But the Helper, the Holy Spirit, whom the Father will send in My name, He will teach you all things, and bring to your remembrance all things that I said to you."

JOHN 14:26 NKJV

Is your faith deeper and stronger than when you first accepted Jesus? While we are responsible for choosing to grow in faith, we can't do it on our own. Jesus promises that the Holy Spirit will teach and guide us if we allow Him to. He will help us remember the spiritual truths we've learned over the years. Fellowship with other Christians also helps us to mature as we share our passions and are encouraged. God wants you to own your faith. Make it real with words and actions.

Jesus, I want to know You intimately. Help me to mature in my walk with You daily. Guide my steps as I seek You through Your Word. Amen.

Day 331

WHAT'S IN YOUR HEART?

Delight thyself also in the LORD: and he
shall give thee the desires of thine heart.
PSALM 37:4 KJV

Too many times we look at God's promises as some sort of magic formula. We fail to realize that His promises have more to do with our own relationship with Him. It begins with a heart's desire to live your life in a way that pleases God. Only then will fulfillment of His promises take place. The promise in Psalm 37:4 isn't intended for personal gain—it is meant to glorify God. God wants to give you the desires of your heart when they line up with His perfect plan. As you delight in Him, His desires will become your desires, and you will be greatly blessed.

Lord, I know You want to give me the desires of my heart.
Help me live in a way that makes this possible.

Day 332

REASONABLE?

*"If you see your friend going wrong, correct him. If he
responds, forgive him. Even if it's personal against you
and repeated seven times through the day, and seven times
he says, 'I'm sorry, I won't do it again,' forgive him."*
LUKE 17:3–4 MSG

As humans, we tend to feel that forgiveness has reasonable limits.
A person who repeats the same offense over and over can't be
very serious when asking for forgiveness! It makes sense from a
human perspective. But fortunately for us, God isn't reasonable.
He forgives our sins no matter how many times we repeat them.
And He asks us to do the same for others.

*Lord, I desperately need Your grace. Thank You for
offering me the gift of forgiveness, over and over again.
Help me to offer Your grace freely to others. Amen.*

Day 333

MEET, PRAY, LOVE

Dear children, let us not love with words
or speech but with actions and in truth.

1 JOHN 3:18 NIV

Sometimes it is true that the action John wrote about in this verse involves words and speech. You can love someone through prayer. At times the most loving thing you can do for a person is pray with them and for them. When a person is deep in grief, holding their hands and praying with them for comfort is worth a whole shop full of flowers. When a person is stuck in depression, seeking them out and thanking God for them can be better than any other act. When a person is anxious, a walk out in the fresh air with a friend and a request to God for calm and assurance can be exactly what the doctor ordered.

Love with actions. But love with words and speech too. And do all of it in truth.

Dear God, help me to have courage to pray with others. Amen.

Day 334

ALL YOU NEED

*"For your Maker is your husband—the LORD
Almighty is his name—the Holy One of Israel is
your Redeemer; he is called the God of all the earth."*

ISAIAH 54:5 NIV

God is the great "I Am." He is all things that we need. He is our Maker. He is our Husband. He is the Lord Almighty, the Holy One, the Redeemer, the God of all the earth. . . . He is not a god made of stone or metal. He is not unreachable. He is present. He is near, as close as you will let Him be, and He will meet your needs as no earthly relationship can. Seek the fullness of God in your life. Call upon Him as your Prince of Peace and your King of Glory. He is all that you need, at all times, in all ways.

*Oh Father, be close to me. Fill the empty spots in my heart.
Be my Husband, my Redeemer, and my best Friend. Amen.*

Day 335

LONGING FOR HOME

This is what the LORD says: "You will be in Babylon for seventy years. But then I will come and do for you all the good things I have promised, and I will bring you home again."

JEREMIAH 29:10 NLT

Sometimes in life we go through periods when we feel out of place, as though we just don't belong. Our hearts feel restless and lonely. We long to go home, but we don't know how. God uses those times to teach us special things we need to know. But He never leaves us in exile. His grace always brings us home.

Father, when I am in a season of loneliness and restlessness, help me to trust You to lead me home. Thank You for Your grace that guides me. Amen.

Day 336
MY LIFE

*I long for your salvation, L*ord*, and your law gives me delight. Let me live that I may praise you, and may your laws sustain me.*
Psalm 119:174–175 niv

Can you really do laundry to please God? Can you really go to work to please God? Can you really pay the bills and make dinner to please God? The answer is a resounding yes! Doing all the mundane tasks of everyday life with gratitude and praise in your heart for all that He has done for you is living a life of praise. As you worship God through your day-to-day life, He makes clear His plans, goals, and dreams for you.

Dear Father, let me live my life to praise You.
Let that be my desire each day. Amen.

Day 337

LIKE AN EAGLE

Like an eagle that stirs up its nest and hovers
over its young. . . . The LORD alone led him.
DEUTERONOMY 32:11–12 NIV

God is big and unsearchable in many ways. Yet He lets us know Him and learn about Him. God is a whispering voice in our souls, and yet His Word shouts truth.

God is huge and grand and impossible to fathom. He is our Father—Deliverer of justice, Ruler of peace, Rescuer and Redeemer.

God is like the eagle, which nurtures its eggs, turning them over at just the right time and keeping them at just the right temperature for proper growth. God is like the eagle, which protects its young chicks, covering them with its wings. God is like the eagle, playing with its young, letting them take chances and then always being there to catch them when they fall.

God is like the eagle, teaching us to fly and carrying us high over the hard parts.

This is the God we call on when we pray.

Dear God, thank You for Your tender, caring love. Amen.

Day 338

ABIDE IN THE VINE

*"I am the vine; you are the branches. If you remain
in me and I in you, you will bear much fruit;
apart from me you can do nothing."*

<small>John 15:5 NIV</small>

The fruit we bear is consistent with Christ's character. Just as apple trees bear apples, we bear spiritual fruit that reflects Him. Spiritual fruit consists of God's qualities: love, joy, peace, patience, kindness, goodness, faithfulness, gentleness, and self-control. The fruit of the Spirit cannot be grown by our own efforts. We must remain in the Vine. How do we abide in Him? We acknowledge that our spiritual sustenance comes from the Lord. We spend time with Him. We seek His will and wisdom. We are obedient and follow where He leads. Abide in the Vine and be fruitful!

*Dear Lord, help me abide in You so that I may
produce fruit as a witness to Your life within me. Amen.*

Day 339

HE IS FAITHFUL

If we are unfaithful, he remains faithful,
for he cannot deny who he is.
2 TIMOTHY 2:13 NLT

Sometimes we treat our relationship with God the same as we do our relationships with other people. We promise Him we'll start spending more time with Him in prayer and Bible study. Soon the daily distractions of life get in the way, and we're back in our same routine, minus prayer and Bible study. Even when we fail to live up to our expectations, our heavenly Father doesn't pick up His judge's gavel and condemn us for unfaithfulness. Instead, He remains a faithful Supporter, encouraging us to keep trying to hold up our end of the bargain. Take comfort in His faithfulness, and let that encourage you toward a deeper relationship with Him.

Father, thank You for Your unending faithfulness. Every
day I fall short of Your standards, but You're always there,
encouraging me and lifting me up. Please help me to be more
faithful to You—in the big things and in the little things. Amen.

Day 340
GOD CARES FOR YOU

"Consider how the wild flowers grow. They do not labor or spin. Yet I tell you, not even Solomon in all his splendor was dressed like one of these. If that is how God clothes the grass of the field, which is here today, and tomorrow is thrown into the fire, how much more will he clothe you—you of little faith!"

Luke 12:27–28 niv

If God makes the flowers, each type unique and beautiful, and if He sends the rain and sun to meet their needs, will He not care for you as well? He made you. What the Father makes, He loves. And that which He loves, He cares for. We were made in His image. Humans are dearer to God than any of His other creations. Rest in Him. Trust Him. Just as He cares for the birds of the air and the flowers of the meadows, God is in the business of taking care of His sons and daughters. Let Him take care of you.

Father, I am amazed by Your creation. Remind me that I am Your treasured child. Take care of me today as only You can do. Amen.

Day 341

MY SOUL TO KEEP

"Let the little children come to me, and do not hinder them,
for the kingdom of God belongs to such as these."
MARK 10:14 NIV

Some of the best prayers you will ever hear may come from the lips of a child. Children speak to God as if they were speaking to their teacher or their grandpa or their dog, Fido. They use the words that come naturally to them and don't try to sound fancy or serious.

Children will pray prayers about the ridiculous and the sublime all at the same time, sometimes even in the same breath. They have no boundaries between them and their Father, no walls to break down, no veils to hide behind.

It is no wonder that Jesus asked for the little children to be allowed to come to Him. How refreshing it must be for God to hear the prayers of hearts and minds that have not yet been made world-weary. We might do well to shed our grown-up manners once in a while and pray with the children: "Now I lay me down to sleep, I pray the Lord my soul to keep."

Dear Father, remind me that I am Your child still. Amen.

Day 342
WHY NOT ME?

God gave Paul the power to perform unusual miracles. When handkerchiefs or aprons that had merely touched his skin were placed on sick people, they were healed.

ACTS 19:11–12 NLT

When his fellow missionary Trophimus fell sick, Paul was given no miracle to help him. When Timothy complained of frequent stomach problems, Paul had no miracle-working handkerchief for Timothy's misery. Paul himself suffered from an incurable ailment (2 Corinthians 12:7), yet he was willing to leave it with God. We too may be clueless as to why God miraculously heals some and not others. Like Paul, we must trust God when there's no miracle. Can we be as resilient as Job, who said, "Though he slay me, yet will I trust in him" (Job 13:15 KJV)? We can—waiting for the day when health problems and bad accidents and death cease forever (Revelation 21:4).

When healing doesn't come, Lord Jesus, give me grace to trust You more. Still I choose hope. Amen.

Day 343

JUMPING HURDLES

God's way is perfect. All the LORD's promises prove true.
PSALM 18:30 NLT

Maybe there are times when you just don't think you can take one more disappointment or hurt. That's the perfect time to draw strength from God and His Word. Meditate on encouraging scriptures, or play a song that you know strengthens your heart and mind. Ask God to infuse you with His strength, and you'll find the power to take another step, and another—until you find yourself on the other side of that challenge you're facing today.

God, give me strength each day to face the
obstacles I am to overcome. I am thankful
that I don't have to face them alone. Amen.

Day 344

CHRIST IS RISEN TODAY!

"He isn't here! He is risen from the dead!"
LUKE 24:6 NLT

The power God used to raise Christ from the dead is the same power we have available to us each day to live according to God's will here on earth. What happened on Easter gives us hope for today and for all eternity. If you haven't accepted Jesus Christ as your personal Savior, take the time right now and start your new life in Christ.

Dear Jesus, thank You for dying on the cross for me and taking away all my sin. You are alive and well, and I praise You today for all You are and all You have done. Amen.

Day 345

PRAYING FOR THE GOSPEL

Join with me in suffering for the gospel, by the power of God.
2 TIMOTHY 1:8 NIV

You may not be called to spread the Gospel in another language in a country far away. Yet you can help those who are. You can pray for them. You can ask God for their protection. You can ask God to give them courage and boldness. You can ask God to give them wisdom to know when to speak and when not to, when to stand out and when to blend in.

Though you may not be called to deliver the Gospel in foreign lands, you may be surprised to find yourself an ambassador for God in your own community. Just because a place is blessed with a church on every block does not necessarily mean all its residents understand the message of love and grace that the Gospel carries with it.

Pray for an opportunity, every day, to share the Gospel or to support those who do.

Dear Lord, help me to spread Your
good news around the world. Amen.

Day 346

FENCES

*"If you keep My commandments, you will abide
in My love, just as I have kept My Father's
commandments and abide in His love."*

JOHN 15:10 NKJV

God's commandments are much like the pasture fence. Sin is on the other side. His laws exist to keep us in fellowship with Him and to keep us out of things that are harmful to us that can lead to bondage. We abide in the loving presence of our heavenly Father by staying within the boundaries He has set up for our own good. He has promised to care for us and to do the things needful for us. His love for us is unconditional, even when we jump the fence into sin. But by staying inside the boundaries, we enjoy intimacy with Him.

*Father, help me to obey Your commandments that are
given for my good. Thank You for Your love for me.*

Day 347

NEVER LOST FOR LONG

For "whoever calls on the name of the LORD shall be saved."
ROMANS 10:13 NKJV

You call out to God, but maybe for a little while you don't hear anything. You may have to listen intently for a while, but eventually you are reassured by His voice. When He calls your name, you know you are safe. You may have to take a few steps in the dark, but by moving toward Him you eventually see clearly. A light comes on in your heart, and you recognize where you are and what you need to do to get back on the path God has set before you.

Heavenly Father, help me to stay focused on You.
Show me how to remove distractions from
my life so I can stay close to You. Amen.

Day 348

JOIN THE TEAM

*Therefore, as God's chosen people, holy and dearly loved,
clothe yourselves with compassion, kindness,
humility, gentleness and patience.*

COLOSSIANS 3:12 NIV

No matter how athletic, beautiful, popular, or smart you are, you've probably experienced a time when you were chosen last or overlooked entirely. Being left out is a big disappointment of life on earth. The good news is that this disappointment isn't part of God's kingdom. Even when others forget about us, God doesn't. He has handpicked His beloved children now and forever. The truth is that Jesus died for everyone—every man, woman, and child who has ever and will ever live. The Father chooses us all. All we have to do is grab a glove and join the team.

*Father, thanks for choosing me. I don't deserve it, but You
call me Your beloved child. Help me to remember others
who may feel overlooked or unloved. Let Your love
for them shine through me. Amen.*

Day 349

THOSE WHO BRING GOOD NEWS

How, then, can they call on the one they have not believed in?
And how can they believe in the one of whom they have not heard?
And how can they hear without someone preaching to them? And
how can anyone preach unless they are sent? As it is written:
"How beautiful are the feet of those who bring good news!"

ROMANS 10:14–15 NIV

When God created our earth, He did indeed ask us to be good stewards of His beautiful world, but over the years our priorities have shifted; we now focus more intensely on the needs of our planet rather than the needs of people and their souls.

As Christians, when we leave this earth and come to meet our Maker face-to-face, He will be more concerned about whether we obeyed His mandate of sharing the Gospel than whether we recycled. Did we spend our days worrying about our carbon footprint or more of our time dealing with the eternal imprint that we were able to leave by sharing the good news of Christ?

Let us always pray for opportunities to share the mercy and love of our Savior with people of all nations—whether it's our neighbors overseas or simply our neighbors across the street.

Lord, remind me of my calling as a Christian. Equip me with the words to say, and give me the boldness to carry out Your plan. Amen.

Day 350
PRAYING WITH CONFIDENCE

*For we do not have a high priest who is unable to empathize
with our weaknesses, but we have one who has been tempted
in every way, just as we are—yet he did not sin. Let us then
approach God's throne of grace with confidence, so that we may
receive mercy and find grace to help us in our time of need.*
HEBREWS 4:15–16 NIV

There is no one like a sister. A sister is someone who "gets you."
But even a sister's love cannot compare to Christ's love. However
you're struggling, help is available through Jesus. Our Savior walked
on this earth for thirty-three years. He was fully God *and* fully
man. He got dirt under His fingernails. He felt hunger. He knew
weakness. He was tempted. He felt tired. He "gets it."

Go boldly before the throne of grace as a daughter of God.
Pray in Jesus' name for an outpouring of His grace and mercy in
your life.

*Father, I ask You boldly in the name of Christ
to help me. My hope is in You alone. Amen.*

Day 351

BRAND-NEW WAYS

Intelligent people are always ready to learn.
Their ears are open for knowledge.
PROVERBS 18:15 NLT

Whether you did well in school or not, you probably rely on your intelligence to get you through life. If you're really intelligent, though, then you will remember that no matter how many years it has been since you graduated, you are never done learning. You need to be open to new ideas, willing to give up old, stale ways of thinking. When you are, you will find God's grace revealed in brand-new ways.

Father, thank You for the gift of knowledge. Instill
within me a heart that yearns to know more—
more of Your love and more of Your grace. Amen.

Day 352

WHAT MATTERS

*In the morning, LORD, you hear my voice; in the morn-
ing I lay my requests before you and wait expectantly.*
PSALM 5:3 NIV

What is the first thing you do each morning? Many of us hit the
ground running, armed with to-do lists a mile long. While it doesn't
ensure perfection, setting aside a short time each morning to focus
on the Father and the day ahead can help prepare us to live more
intentionally. During this time we, like Jesus, gain clarity so that
we can invest our lives in the things that truly matter.

*Father, help me to take time each morning to focus on
You and the day ahead. Align my priorities so that the
things I do will be the things You want me to do.*

Day 353

GENTLE AND HUMBLE OF HEART

But God chose the foolish things of the world to shame the wise;
God chose the weak things of the world to shame the strong. God
chose the lowly things of this world and the despised things—
and the things that are not—to nullify the things that are.

1 Corinthians 1:27–28 niv

Throughout the Bible, we see God selecting people for His tasks who might be considered by the world's standards to be very unwise choices. Yet God does not see people the way we see them. He may pick someone—whom the world despises because of a lack of wealth or fame or academic accolades or clever wit or worldly savvy—and raise her up to show a haughty society just how foolish their pride looks.

The Gospel of Matthew says, "Blessed are the meek, for they will inherit the earth" (5:5 niv). Jesus called Himself gentle and humble of heart. So, if you are feeling unfit for duty because you are humble and lowly by the world's standards, take heart. God loves the meek. If you feel you are lacking in a gentle and selfless spirit, just ask God for one, and He will be pleased to give it to you.

Father, thank You for loving misfits, outcasts, and
sinners. Cultivate in me a spirit of humility. Amen.

Day 354

THE PERFECT REFLECTION

"Give careful thought to your ways."
HAGGAI 1:7 NIV

As we give careful thought to our ways, we should first look back to where we have come from and reflect on God's work in our lives. We are on a journey. Sometimes the road is difficult; sometimes the road is easy. We must consider where we were when God found us and where we are now through His grace. Even more importantly, we must think about the ways our present actions, habits, and attitude toward God reflect our lives as Christians. Only when we are able to honestly assess our lives in Christ can we call on His name to help perfect our reflection.

*Dear Lord, help me to look honestly at the ways
I live and make changes where necessary. Amen.*

Day 355
TRUTH

"You will know the truth,
and the truth will set you free."
JOHN 8:32 NLT

What lies do you believe about yourself? How might those lies be preventing you from experiencing God's plan for *your* life? The next time you're tempted to believe a lie, write it down. Then find a scripture passage that speaks truth over the situation. Write that scripture verse across the lie. Commit the truth to memory. Over time God's Word will transform your thinking and you'll begin to believe the truth. Then something amazing will happen— you'll be set free.

Father, thank You for the truth Your Word speaks about my life.
Open my eyes to the truth and help me to believe it. Amen.

Day 356
HIS HEALING ABUNDANCE

*"Behold, I will bring it health and healing; I will heal them
and reveal to them the abundance of peace and truth."*
JEREMIAH 33:6 NKJV

If we confess our sins to God, He will bring relief to our souls.
When we're distressed, we have Jesus, the Prince of Peace, to give
us peace. When our emotions threaten to overwhelm us, we can
implore Jehovah-Rapha—the God Who Heals—to calm our
anxious hearts. When we're physically sick, we can cry out to Jesus,
our Great Physician. Whether our problems affect us physically,
spiritually, mentally, or emotionally, we can trust that God will
come to us and bring us healing. And beyond our temporal lives,
we can look forward with hope to our heavenly lives. There we
will be healthy, whole, and alive—forever.

*Jehovah-Rapha, thank You for healing me.
Help me do my part to seek health and the
abundance of peace and truth You provide.*

Day 357

A TREE PLANTED BY THE WATER

*"But blessed is the one who trusts in the LORD, whose
confidence is in him. They will be like a tree planted by
the water that sends out its roots by the stream. It does not
fear when heat comes; its leaves are always green. It has
no worries in a year of drought and never fails to bear fruit."*

JEREMIAH 17:7–8 NIV

The streams have dried up. The land is barren. Rain is only a memory. The cicadas may be the only thing left singing. Have you ever experienced this kind of serious drought? If you have, it is unforgettable. Drought is a brutal force of nature—an unforgiving taskmaster. That is the way of the world. It will steal your strength until you are weak and vulnerable and fruitless.

Yet prayer can build up our trust in the Lord. He is our strength in a harsh and desolate land. If we faithfully spend time with Him and His good Word, we will be like that tree in the book of Jeremiah. We will be that tree planted by the water that sends out its roots by the stream. A tree that does not fear the heat or a year of drought. It's the kind of tree that will never fail to bear fruit.

*Lord, when I'm feeling lost and dried up, give me the
strength to turn to You with outstretched arms and to
have faith in Your goodness and love. Amen.*

Day 358

ALWAYS THINKING OF YOU

What is man that You are mindful of him,
and the son of man that You visit him?

PSALM 8:4 NKJV

Have you ever wondered what God thinks about? *You* are always on His mind. In all you think and do, He considers you and makes intercession for you. He knows the thoughts and intents of your heart. He understands you like no other person can. He knows your strengths and weaknesses, your darkest fears and highest hopes. He's constantly aware of your feelings and how you interact with or without Him each day. God is always with you, waiting for you to remember Him—to call on Him for help, for friendship, for anything you need.

Lord, help me to remember You throughout
my day. I want to include You in my life
and always be thinking of You too. Amen.

Day 359
CHOOSE GRACE

*And a servant of the Lord must not quarrel but must
be kind to everyone, a good teacher, and patient.*

2 TIMOTHY 2:24 NCV

Some days we can't help but feel irritated and out of sorts. But no matter how we feel on the inside, we can choose our outward behavior. We can make the decision to let disagreements go, to refuse to argue, to act in kindness, to show patience and a willingness to listen (even when we feel impatient). We can choose to walk in grace.

*Lord, help me to be kind to everyone, to be a good teacher,
and to be patient with others. Thank You for Your
grace that allows me to be Your servant. Amen.*

Day 360

LASTING TREASURE

"Beware! Guard against every kind of greed.
Life is not measured by how much you own."

LUKE 12:15 NLT

The Lord never meant for us to be satisfied with temporary treasures. Earthly possessions leave us empty because our hearts are fickle. Once we gain possession of one thing, our hearts yearn for something else. Lasting treasure can only be found in Jesus Christ. He brings contentment so that the treasure chests of our souls overflow in abundance. Hope is placed in the Lord rather than our net-worth statement. Joy is received by walking with the Lord, not by chasing some fleeting fancy. Love is showered upon us as we grab hold of real life—life that cannot be bought but that can only be given through Jesus Christ.

Dear Lord, may I be content with what You
have given me. May I not wish for more material
treasures but seek eternal wealth from You. Amen.

Day 361

SEASON OF SINGING

"See! The winter is past; the rains are over and gone.
Flowers appear on the earth; the season of singing
has come, the cooing of doves is heard in our land."
Song of Songs 2:11–12 niv

Is your life caught up in a cold winter that never seems to end?
Then snuggle up in a warm blanket of truth.

God provides you with His mighty Word to heat and stir your
soul. He offers you the safe and sheltering knowledge of eternal
life through Christ. Under the lamp of these truths we can sing
in our hearts, knowing spring is near.

In time, the cold will go. The ice will thaw. The rain will cease,
and the sun will burst boldly through the clouds in rays of pure
gold. The earth will turn a lush green, and flowers will spring up
in a profusion of color. Even the gentle cooing of doves will be
heard all through the land. What beauty. What hope. What joy.

God, give me joy and patience in the long winters of
life. Remind me of Your steadfast presence, and may
Your Word strengthen and comfort me. Amen.

Day 362

YOUR GLORIOUS FUTURE

"No eye has seen, no ear has heard, and no mind has imagined what God has prepared for those who love him."

1 CORINTHIANS 2:9 NLT

God's promise for our future is so magnificent we can't even comprehend it. He has great plans for each of us, but we often become paralyzed by fear. Why? Because the past seems more comfortable. Because the future is uncertain. While God doesn't give us a map of what our future is like, He does promise that it will be more than we could ever ask or imagine. What steps of faith do you need to take today to accept God's glorious future for your life?

God, Your ways are not my ways, and Your plans are too wonderful for me to even comprehend. Help me to never be satisfied with less than Your glorious plans for my life.

Day 363

SWEATING THE SMALL STUFF

*Blessed are all who fear the Lord, who walk in
obedience to him. You will eat the fruit of your
labor; blessings and prosperity will be yours.*

PSALM 128:1–2 NIV

The Lord showers us with many blessings each day—family, friends, education, employment, good health, and a beautiful earth. But despite the gifts He gives, it's easy to get bogged down in the little things that go wrong. We're all human, and we sometimes focus on all the negatives rather than the positives in life. Next time you're feeling that "woe is me" attitude, remember that you are a child of God. Spend some time counting all the wonderful blessings that come from the Lord rather than the headaches from this earth.

*Father, thank You that I am Your child. Remind me each
day to count the many blessings You shower upon me,
rather than focusing on the negatives of this world. Amen.*

Day 364
RADIANT

"If you are filled with light, with no dark corners, then your whole life will be radiant, as though a floodlight were filling you with light."
Luke 11:36 nlt

We all have dark corners in our lives we keep hidden. We hide them from others. We hide them from God, and we even try to hide them from ourselves. But God wants to shine His light even into our darkest, most private nooks and crannies. He wants us to step out into the floodlight of His love—and then His grace will make us shine.

Heavenly Father, fill me with light. Shine Your radiance on all my dark corners. Remove my shame, and help me to bask in the light of Your love. Amen.

Day 365

SENSE OF BELONGING

*"All that the Father gives Me will come to Me, and the
one who comes to Me I will by no means cast out."*

John 6:37 NKJV

We belong to Christ. When the Father calls us to come to Jesus,
we belong to Him. This is an irrevocable transaction. We are His,
given to Him by the Father. He does not refuse to save us. He
will not refuse to help us. No detail of our lives is unimportant to
Him. No matter what happens, He will never let us go. Like the
enduring love of a parent—but even more perfect—is the love of
Christ for us. He has endured all the temptations and suffered all
the pain that we will ever face. He has given His very life for us.
We can live peacefully and securely knowing we belong to Him.

*Lord Jesus, I confess I often forget that I belong to
You and how much You love me. Help me to rest
in Your everlasting love and care. Amen.*

SCRIPTURE INDEX